IMAGES
of America

STEELVILLE

ON THE COVER: For years, the Meramec River has attracted tourists to the Steelville area, making tourism one of Steelville's major industries. Pictured here on the Meramec River, just below the Wildwood Bluff, are Teddy Prietsch and Mary Virginia (in canoe), Pauline Clymer, Opal Moss, Rowena Bass, and Sandy Avis, the canoe owner. (Courtesy of the author.)

IMAGES
of America

STEELVILLE

Bob Bell and Emily Bell

ARCADIA
PUBLISHING

Published by Arcadia Publishing
Charleston, South Carolina

Printed in the United States of America

Library of Congress Control Number: 2009943882

For all general information, please contact Arcadia Publishing:
Telephone 843-853-2070
Fax 843-853-0044
E-mail sales@arcadiapublishing.com
For customer service and orders:
Toll-Free 1-888-313-2665

Visit us on the Internet at www.arcadiapublishing.com

*Dedicated to the memory of Fritz and Helen Jonas. They touched
so many lives through their faith and love of Steelville.*

CONTENTS

Acknowledgments 6

Introduction 7

1. The Beginning of Trains 9

2. Destruction and Devastation 19

3. Becoming Crawford's Main City 25

4. Home Sweet Home 55

5. Child's Play 65

6. The Ways of Life 79

7. Vacation Destinations 91

8. The End of an Era 111

Acknowledgments

It all began in the mid-1980s after I graduated from the University of Columbia and came home. My father had always taught me the importance of being involved in your community and giving back, saying it is always better to give than receive. So after my return, I started to volunteer at the local senior meals program, where I had the honor of getting to know so many wonderful and talented individuals who had given of themselves to this community.

Then the Peoples Bank came along and hired Pete Lea, a proud veteran of World War II in the Pacific, and one of the most caring, motivated, and outspoken individuals Steelville has ever had. The bank wanted to use old photographs of the area to decorate the bank, as it was located in an old historic building on Main Street. Pete started asking around. Fritz Jonas had a few old photographs that I had the opportunity to see, and that was it, I was hooked.

I have been collecting old photographs of Steelville and the surrounding area ever since, which has been over 25 years now.

I would like to acknowledge the many people who have let me copy their photographs over the years. I would like to thank my many postcard friends Trenton Boyd, Alan Banks, and John Bradbury, who have searched many boxes of postcards for just the right card. I would like to acknowledge Herman Lark, who had the vision to pick up a camera and take photographs and, more importantly, keep them safe over all these years. I would like to acknowledge all of those who have just given me photographs, like Kem Schwieder, Phil Bass, Haley Saltsman, and Pat Clinton. Thanks also goes to Mary McInnis for editing.

I want to acknowledge Bill Freeman for putting up with my questions about dates, owners, and events over all these years. Without him, I am sure this historical document would be very flawed.

I mostly want to acknowledge my daughter Emily Bell for her talent, skills, and patience.

INTRODUCTION

Steelville, Missouri, was founded in 1835 when James Steel sold part of his property in the Valley of Springs to the Court of Crawford County. However, the area of Steelville formed long before then. The pushing of the earth's crust formed the hills, and the washing of the creeks created the valley. The valley was a place for the Native Americans to live a full and self-sustaining life. They had plenty of wildlife, natural habitats in the caves, and an abundance of fresh water from the springs. Just like the Seven Hills of Rome, the valley is surrounded by seven hills that protect it.

In the early 1820s, settlers of European descent arrived after a merchant from Ohio by the name of Thomas James had camped on the same grounds as a band of Shawnee Indians. He had heard them tell stories of swift water, tall trees, and most importantly, the red coloring in their decorative paint. It could only mean iron ore and all the ingredients it takes to make an iron works: waterpower, trees for charcoal, and hematite ore. Maramec Springs Iron Works was constructed 12 miles west of the Valley of Springs and was put into operation in 1826, which was just five years after the state of Missouri had been accepted into the United States.

After the pig iron had been forged, it was shipped by wagon trains due east to the Mississippi in order to be floated downstream to New Orleans or other factory locations, where it was then hammered out into shovels, axes, and wheels. The wagon trains traveled though the valley, which was only a day trip away from Maramec Springs. These trains were also in need of new supplies like meat, bread, and fresh water for the horses and the men to drink.

The next major, influential settler, William Britton, did not enter the Valley of the Springs until 1833. Even though Missouri became a state in 1821, much of it was still Native American territory until the early 1830s, when the last tribes were pushed out. Britton built a small log cabin about 14 by 16 feet, and a small gristmill next to it. He also built a small dam on the Yakin Creek, just 40 yards east of the Steelville Spring. With this gristmill, the other frontiersmen from the surrounding area were able to bring their grist for grinding. James Steel, Steelville's namesake, was the next known settler to enter the valley. He bought 40 acres of land in the valley from the government in the early 1830s, and set up a small mercantile shop on what is known as Main Street today.

The County of Crawford had been formed on January 29, 1829, and stretched all the way from Washington County to the western state line. In those days, counties were formed as frontiersmen entered and took up residence. Until enough people were located in an area to form a full county that demanded a permanent county seat, the county court would simply meet in private residences, like those of William Harrison or Snelson Brinker.

On December 16, 1835, Crawford County bought James Steel's 40 aces. After recording the deeds in the court on December 18, 1835, the town was laid out and plotted to its current form. Not long afterwards, the great men who would give the settlement of Steelville its roots started to cross the mountains, rivers, and hills from Kentucky, Ohio, and Tennessee, finding their way

to the Valley of Springs. These men included Lewis Pinnel, Elias Matlock, Peter Whittenburg, and James Davis.

The first saddle and harness maker, James Johnson, came in 1838. Peter Whittenburg took over James Steel's store in 1842 after Steel decided to move farther west. A. W. Johnson was the first blacksmith to set up shop in 1847. James Davis built the first hotel of logs in the early 1850s, which was when the settlement had reached the size of approximately 300 settlers.

Steelville was now on its way to becoming a center of commerce. By 1857, the county had built its first courthouse, a beautiful two-story, brick building. After the first courthouse was consumed by fire, the present-day courthouse replaced it in 1874. It was built for $10,000. Main Street was also taking shape with shops, a hotel, and houses lining the street east and west. Church congregations were gathering on the Sabbath to honor God. In 1851, St. Louis Cumberland Presbyterian formed the Steelville Academy with the construction of an amazing, two-story, brick building on the corner of Seminary Street and Keysville Road. Then the St. Louis, Salem, and Little Rock Railroad came straight through town on its way to Salem in 1872. The little settlement that wanted so much to survive was making its mark in the valley. Steelville had all of the following: fresh water from the springs; stability of the courts; commerce through the help of the railroad; schools for all ages, which included the Steelville Academy and the Steelville Normal and Business Institute; churches for the faithful; and a newspaper from which residents obtained helpful information. It was no longer a settlement but a town; however, danger and devastation were soon on their way to Steelville.

On July 7, 1898, after a heavy rain, a logjam formed on the recently built railroad trestle up the valley, just less than a quarter-mile west of town. It is said that the logjam had formed a pool of water that backed up in the valley. The dam broke in the middle of the night, while all of Steelville lay quite. Homes were washed off their foundations, trees were uprooted, and lives were ruined. Steelville lost a total of 13 people that night, with the bodies washed miles downstream, including men, women, and children. Steelville was determined to survive and rebuild, readying itself for a new century.

Then came more destruction with the great fire of Main Street on May 13, 1904. It started at 9:20 p.m. in Dr. Coffee's little two-story office building and ended up destroying almost all of the business district, leaving nothing but ash. The fire obliterated general stores and their inventories, as well as the beautiful and elegant Gibson Hotel, which had just recently being completed in 1890. It was a great disaster, but not a single life was lost. Once again, Steelville had to rebuild, but this time the terrible disaster became Steelville's greatest advantage. The town rebuilt of brick and stone, with all the main blocks having been rebuilt by 1910. The little settlement that could had survived.

One

THE BEGINNING OF TRAINS

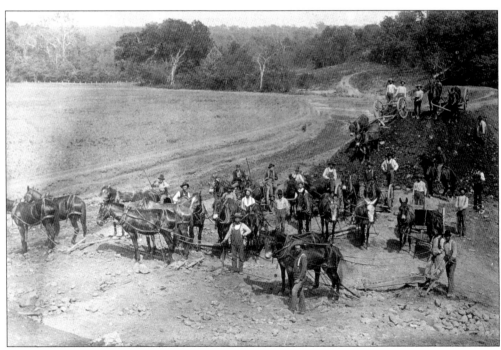

The railroad that passes through Steelville is the St. Louis, Salem, and Little Rock Railroad, which extended southward from the Cuba junction. An organization of men from Pennsylvania established the St. Louis, Salem, and Little Rock Railroad Company in 1871, and after money was raised through township bonds, construction started in the spring of 1872. This photograph shows men building the roadbed for this branch.

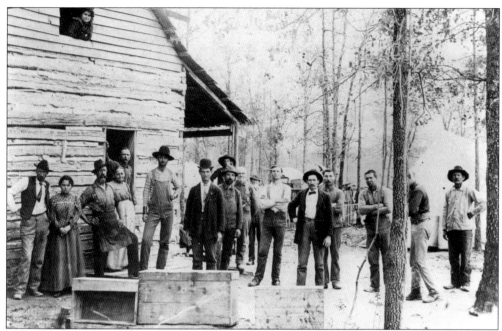

During the construction, J. W. Blanchard was appointed superintendent, with E. B. Sankey as chief engineer. Construction lasted from 1872 until July 1873, ending at Simmons' Iron Mountain, which was just one mile south of Salem. Shown here are workmen on the "Salem Branch." Eighth from the left is W. R. Vaughn.

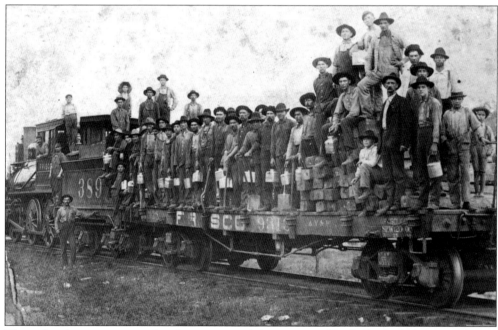

The railroad was never completed to its original destination of Little Rock, Arkansas. After 14 years of running the Salem Branch, the St. Louis, Salem, and Little Rock Company sold the branch to the St. Louis and San Francisco Railroad on December 1, 1887. It was then renamed as the Salem branch off the "Frisco" line.

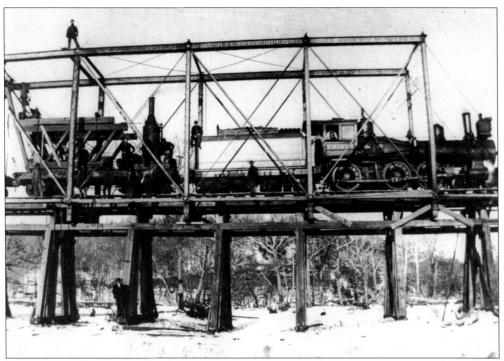

In the photograph above, taken in approximately 1872, workmen pose with an engine on the newly constructed railroad bridge. This original bridge crossed the Meramec River where Bird's Nest Lodge is now located. The original bridge was eventually replaced with the bridge below.

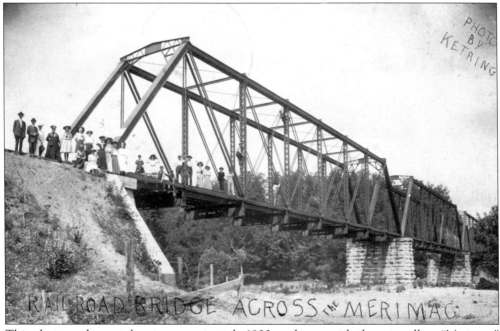

This photograph was taken in approximately 1900, and even with the misspelling "Merimac," it is known as the bridge for the Salem Branch. The stone beams that supported the bridge can still be found along the Meramec River, near Bird's Nest Lodge.

Frisco Depot Cuba Mo.

The original railroad connecting St. Louis, Salem, and Little Rock passed through Cuba, Missouri, leading toward Steelville, then Salem. It was in Cuba that the railroad broke off from the main route and headed south.

DEPOT STEELVILLE MO.

In Steelville, the railroad was placed north of and parallel with Main Street. The depot was rebuilt after Steelville experienced a great flood in 1898. It was placed south of the tracks facing north, as shown. This photograph was taken around 1910.

The 41-mile trip from Cuba to Salem included passing through the town of Wesco. Pictured here is Wesco's depot around 1903.

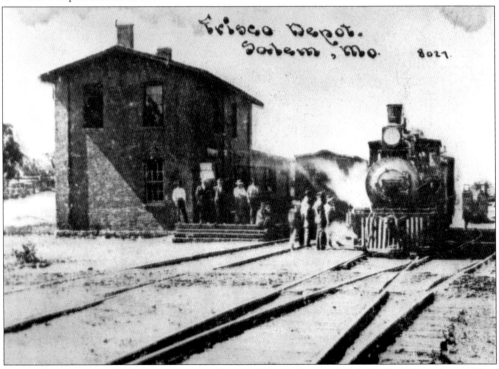

Once the trains reached the end of the line in Salem, they would find the Salem depot. This postcard calls the depot "Frisco." The depot was given to the railroad after the sale of the St. Louis, Salem, and Little Rock Company to the St. Louis and San Francisco Railroad in 1887.

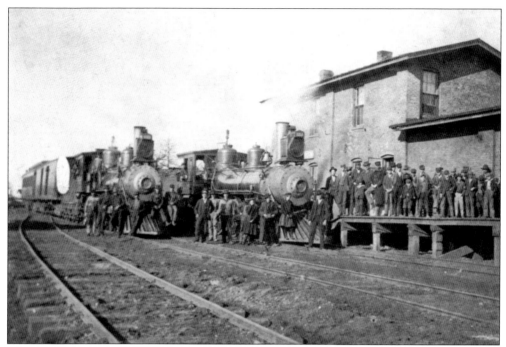

These two trains carried passengers in 1893 along the Salem branch. A gentleman named W. S. Elayer, a former conductor for the branch, originally owned the photograph. Unfortunately, he cannot recall the reason for the crowd.

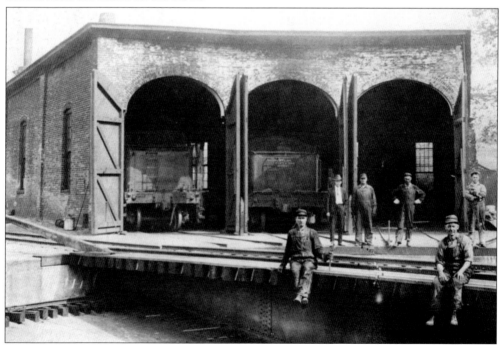

Placed one mile south of the Salem station was the roundhouse, pictured here with workers. Engines were stored and rotated in order to return back to Cuba. Eventually, the terminal was moved to Cuba, Missouri, and this building has since been torn down.

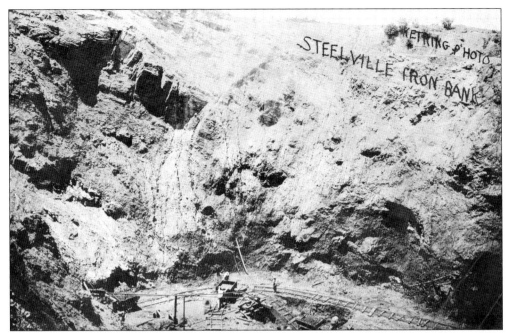

With the addition of railroads into the area, the iron ore industry was able to expand. One of the largest operations was the Cherry Valley Bank. Often mistakenly called a mine, this area required little construction of veins due to ore being heaped or "banked" up near the top of the ground.

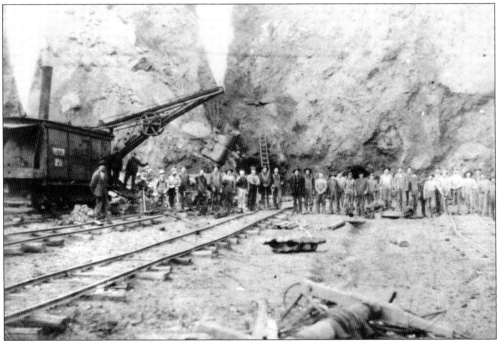

From Cherry Valley Bank, a six-mile railroad was constructed to Midland, where a furnace was placed to create cast iron from the ore. The track ran straight into the bank, where large pieces of ore would be placed in ore cars that would then return straight to Midland. This picture shows the track in the bank along with the workers.

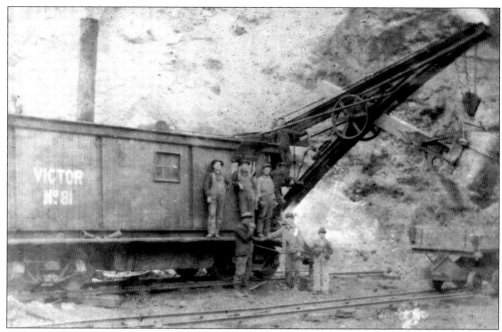

Cherry Valley Bank produced mostly red ore but also blue. This was obtained by stripping away top layers of earth to reach the large ore pieces. The process was achieved with the help of steam shovels, pictured here. From 1878 to 1918, the bank was estimated to have produced approximately 1 million tons of iron ore.

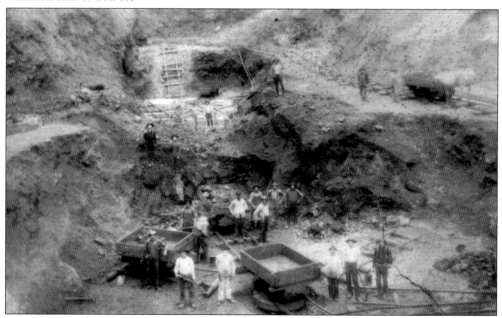

From 1878 to 1904, Cherry Valley Bank was owned and operated by Meramec Iron Mineral Company of St. Louis, and supervised by E. T. Hernden. It employed 150 miners and 50 laborers, each earning between 75¢ and $3 a day. In 1904, Sligo Furnace Company leased the bank, continuing to produce iron ore until 1918. Pictured here are workers employed under Meramec Iron Mineral Company.

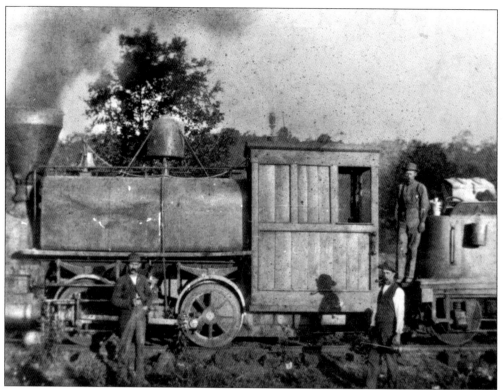

Construction of the Cherry Valley Railroad began in 1877 and was completed on August 25, 1878. This reduced the bank's transportation costs to their greatest purchaser, Midland Furnace. Pictured here is a "Dingo," which was used to transport the iron ore. From left to right are Charles R. Purvines, James Considine, and Jack McCoy.

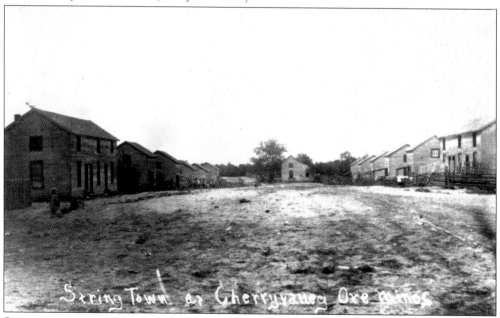

Stringtown was created to house the workers for Cherry Valley's Iron Ore Bank.

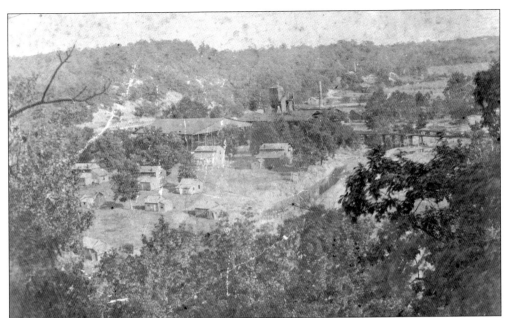

Iron ore production was a popular local industry; however, when the depression hit in the 1870s, many iron ore companies went bankrupt. St. Louis investors saw this as an opportunity and built the Midland Furnace. On April 10, 1875, the furnace was "blown in" but faced problems and closed in August for repairs. The depression slowed repairs, but on April 21, 1877, the furnace started production again and continued until January 22, 1894.

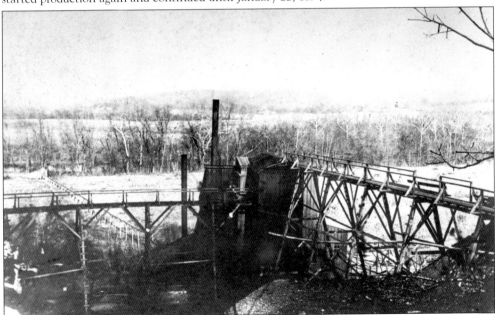

Unlike the typical square shaped furnace, Midland constructed a round, firebrick furnace held together with iron bands. In 1879, the furnace became known as one of the most efficient in the United States, using comparably less fuel to create 45 tons of iron per day. This created large profits until 1893, when another financial recession hit and decreased the prices of iron. The company decided to close due to the decreased prices and the increased costs of transporting wood.

Two

DESTRUCTION AND DEVASTATION

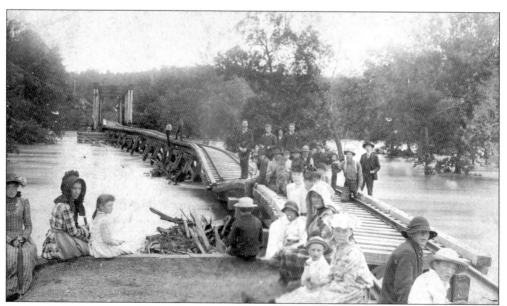

On July 7, 1898, in the middle of the night, Steelville experienced one of its greatest devastations. Large amounts of water gushed unexpectedly into the city, leaving buildings knocked off their foundations and mud and slime everywhere. According to the *Crawford Mirror* at the time, the estimated loss easily reached $200,000, with 13 lives lost.

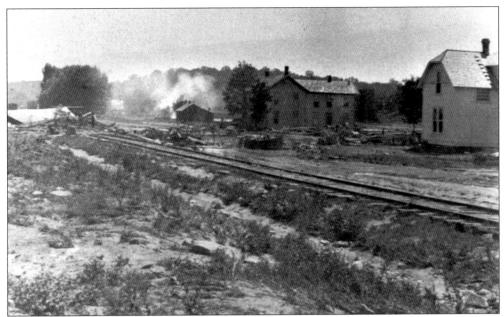

The flood was the outcome of the railroad's "unheeded warning." The railroad had been warned that existing small culverts and waterways were not sufficient for the heavy rains in the area; however, construction continued. In 1898, after heavy rains on July 7, a logjam had built up on the railroad trestle west of town. Late in the night the dam broke, sending vast amounts of water toward the town. This photograph shows complete destruction of the depot.

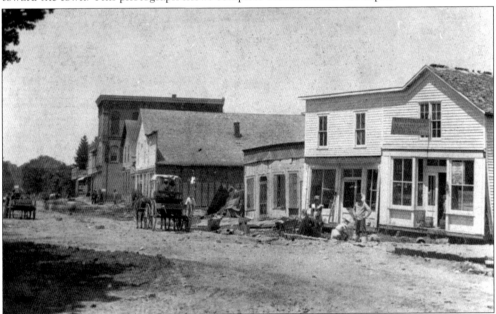

The raging waters heavily hit Main Street. Webb and Ferguson Hardware (at right) experienced the greatest damage. Connected to the post office (second from right), the buildings were picked up and turned on a 45-degree angle. This allowed water to gush in, leaving nothing but ruined goods. Other businesses that experienced heavy damages included Halbert and Sander's Grocery, W. H. Davis's furniture store, Cooper and Son Hardware, and W. H. Ferguson's warehouse.

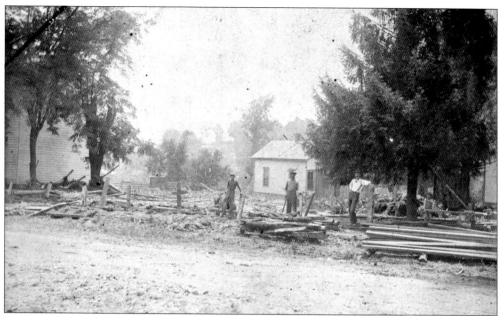

Many homes along Main Street were found to have been carried away from their previous locations or reduced to pieces of ruined timber, like Charlie Everson's home. The picture shows Charlie with his two brothers. While some found security in attics, Samuel Dicus, a one-legged soldier, stood on furniture with water up to his neck for hours. Others found sanctuary in trees or neighboring homes until the water receded.

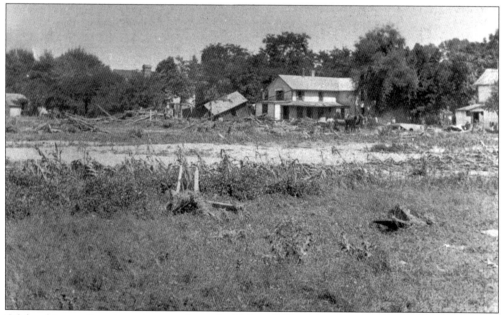

Of the thirteen lives lost, six came from the Taft and Wood families. Their adjacent homes were both lifted from their foundations and carried down the Yadkin. The Taft family tried floating on a bed but got swept away by the current. Mrs. Taft and the three Taft children were killed. Mr. Woods, holding onto his wife, child, and baby, swam a quarter mile until separated from his family by a tree. He was the only survivor of his family.

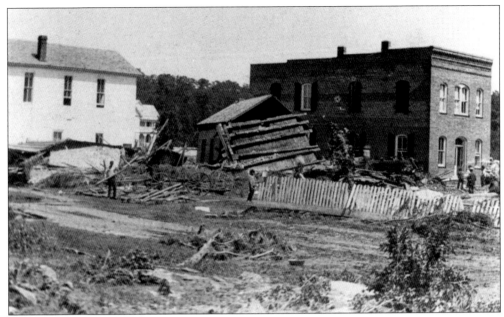

The *Crawford Mirror* described the scene as follows: "Streets were piled with debris, some places 20 feet high . . . buildings were found standing in fields a mile away from their foundations. All fences gone, shade trees and gardens were utterly ruined . . . stores were swept of their goods . . . and thousand other articles strewed over a frightful, desolated waste. Homes were filled with agonized mourners, and frantic people were running to and fro calling for their missing loved ones."

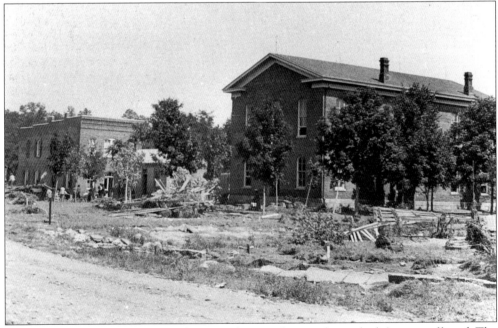

While the waters threw about most homes and stores, the courthouse (right) was unaffected. The fence in the courtyard had disappeared, but all records remained undamaged by the waters. Only a few of Steelville's houses, placed on hillsides, survived as untouched as the courthouse. Nearly all the town's residents suffered damage to their property.

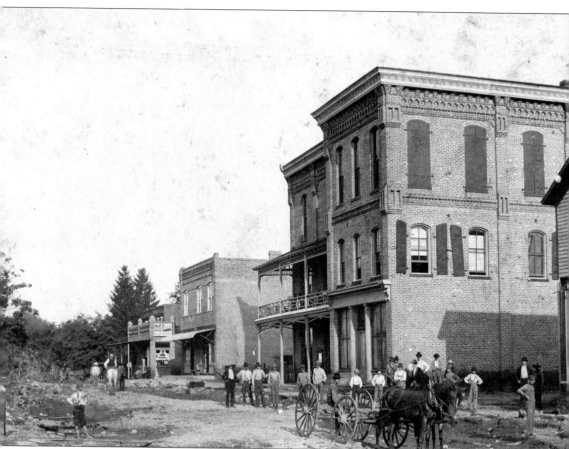

The Gibson Hotel (right) was considered Steelville's grandest building. Ads for the hotel describe the building including "a large office room, two sample rooms, dining room and kitchen, wash room and two larger parlors, twenty guest rooms, and an opera house." Rooms were said to be elegantly furnished with high ceilings. Housing many prospective students for the Steelville Normal and Business Institute, the hotel also welcomed guests from St. Louis during the summer months. During the flood, the hotel received damage to its carpets, provisions, and furniture. Even with great devastation throughout the town, the *Crawford Mirror* claimed the Stough family had the "most terrible experience." Will Stough and his new wife were being visited by Will's brother Luther, who was to be married the following Sunday; by Lulie Tucker and her baby from St. Louis; and by Charley Abrams's young daughter May. The family and guests were unable to escape to higher ground. Since none could swim, their only hope was to hang onto the house's roof. After floating half a mile, the house came apart, separating the people. Will was able to keep his head above water for two miles, making him the only survivor of the group.

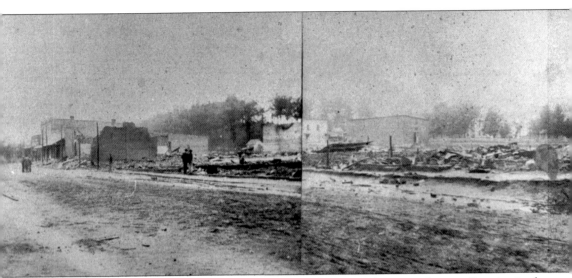

On May 13, 1904, at 9:20 p.m., Steelville witnessed its second greatest disaster. Starting in the back of the Coffee building, which was being remodeled to become W. L. Wingo's drugstore, a fire quickly spread through the complete business district. The two-story Coffee Building was positioned between the two-story Haley Brothers and Company store and the two-story J. C. Davis Furniture Store. Within minutes, these three buildings were engulfed in flames. Men and women rushed to the scene to save goods and create bucket brigades; however, the intense heat made it impossible to extinguish the flames. Of Steelville's 43 businesses, 23 were destroyed. On the north side these included the Coffee Building, Haley Brothers and Company, J. C. Davis Furniture Store, Halbert's Store, Todd's Grocery Store, Horn's Drugstore, and the Gibson Hotel. The south side businesses that were destroyed included Bass Brothers; Bass and Russell's Real Estate Office; Davis's Barbershop; Puckett's three buildings, including the saloon; and many more. Total damages were estimated to be near $75,000. Some businesses were able to collect insurance, but many found insurance only covered half the damages. While rebuilding, most businesses set up tents or shared space with still-standing buildings.

Three

BECOMING CRAWFORD'S MAIN CITY

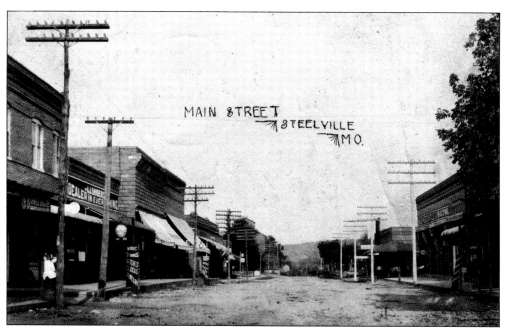

Through the years, Steelville's businesses have come and gone, but many of the buildings have remained the same. This is due to the fact that after the fire of 1904, the City of Steelville ordered all businesses to be reconstructed with brick, allowing the view of Main Street to remain similar throughout the years.

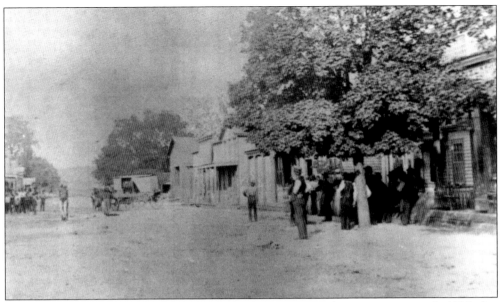

As the oldest known photograph of Steelville's Main Street, taken in approximately 1890, this shows a gentleman from a traveling circus act walking across a tight rope. During this time, trees lined Main Street, and Steelville's businesses were all constructed with wood. The buildings lining the right side of the photograph include, from left to right, Joe Bass Livery Barn, Whitecotton Barbershop, Bass and Norvell's Saloon, Saltzer's Butcher Shop, Vaughn Brothers, J. C. Lark's Store, and S. P. Brickey's house.

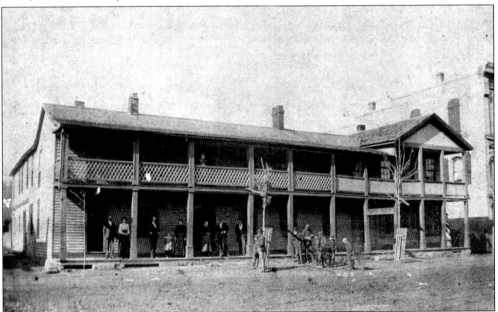

Originally, James Davis built the Steelville Hotel as a brick and log cabin hotel in 1840. After running the business for four years, Davis sold the hotel, which saw multiple owners over the years. Some of the past owners included the Day family, who purchased the hotel in 1878; the Bass family, who took over in 1884; and then the Self family. This photograph was taken between 1890 and 1898.

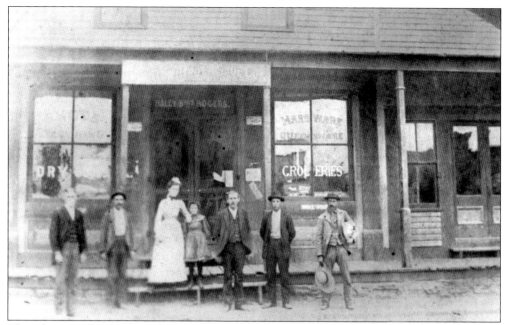

This photograph was taken before 1898, at the corner of Seminary Street and Main Street, the location of Haley and Rogers General Merchandise. William M. Haley, Wilson Haley, and Rogers, the proprietors, are shown here. This two-story, wood-framed building was one of the few survivors of the flood of 1898 but later burned down in 1904 during the fire that destroyed a large part of the city. The Haley brothers eventually bought Rogers out, and the store became Haley Brothers General Merchandise.

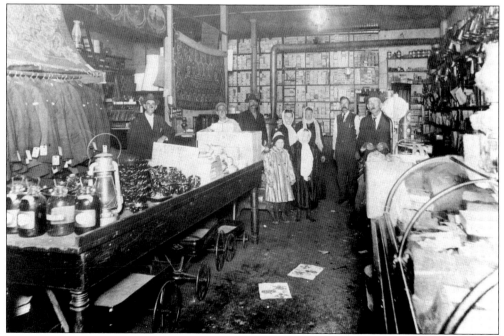

The Haley and Rogers store carried a wide range of products including lanterns, children's wagons, boxed goods, and much more. This photograph of the interior was taken around 1895.

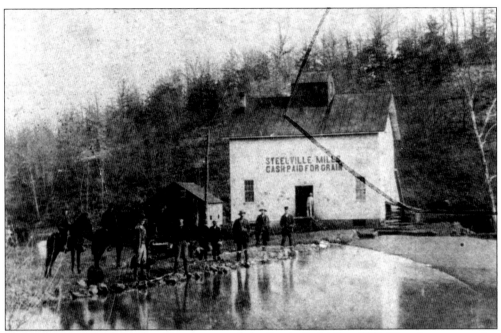

A man named E. Hiller originally constructed the Steelville Mill in 1879. This three-story, plus a basement, building was used as a buhr mill, which took the grain the farmers brought in and ground it until flour was made, until 1886. During this time, Jacob R. Hiller, son of E. Hiller, purchased and installed two sets of rollers.

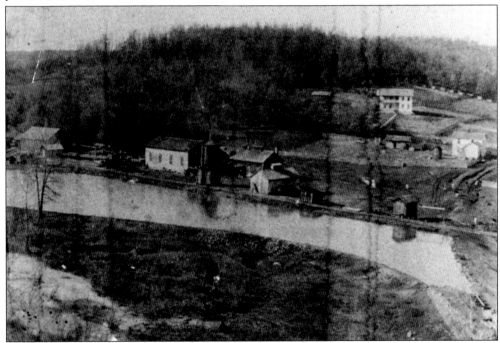

In the late 1800s, the mill was producing up to 20 barrels of flours a day through waterpower. This photograph shows the back of the Steelville Mill beside the Water Pond. The tracks and small water tower were part of the Frisco Line in what is known as Sankey.

Built in October 1884, the Bank of Steelville was 24 by 36 feet and cost approximately $1,900 to build. Pictured are Pres. G. W. Matlock, Vice Pres. J. T. Coffee, and cashier Thomas R. Gibson. Upon opening, the Bank of Steelville held $10,000 in original capital stock with 12 stockholders.

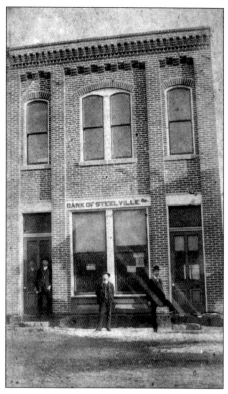

Pictured fifth from the left, R. G. Jonas immigrated from Merency, Austria, in 1890 with his baker's bowl in hand. After settling in Steelville, he opened Steelville Valley Bakery with John Bordas. Located beside the Bank of Steelville, the bakery offered fresh bread, pies, and cakes, along with hot and cold lunches daily. Later this building would become the West End Tavern, located on the corner of College and Main Streets.

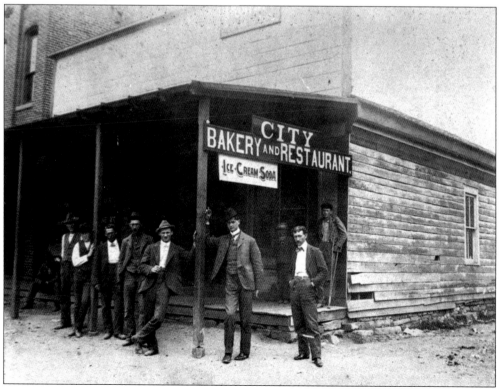

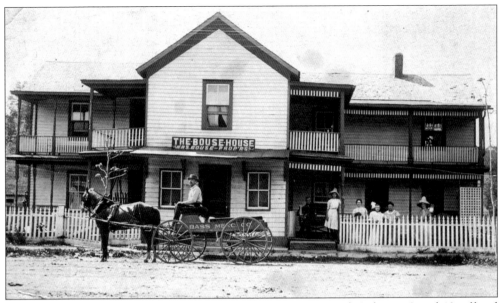

The Bouse House Boarding Home, located at the intersection of Highways 8 and 19, offered housing and meals to the citizens of Steelville. There is a story that tells of Martha Bouse cooking up "Uncle John" Wood's catch of the day, and by the time the plate arrived in front of Uncle John, the fish was gone.

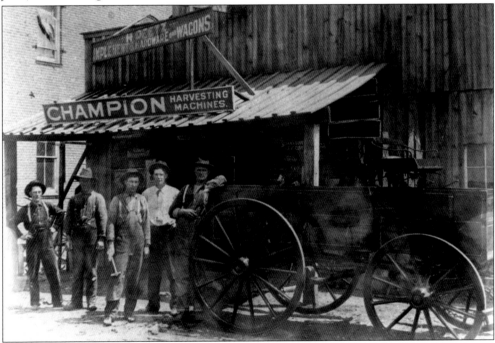

Henry Peetz Implements and Wagons was located near the Yadkin Creek, facing the courthouse on Third Street. The business originated with Henry's father, Fritz Peetz. The building pictured was built after the first building was destroyed during the flood of 1898. As a blacksmith, Henry Peetz constructed wagons from scratch. When automobiles were introduced to the economy, Peetz started selling cars and even allowed customers to trade in their wagons for a new car.

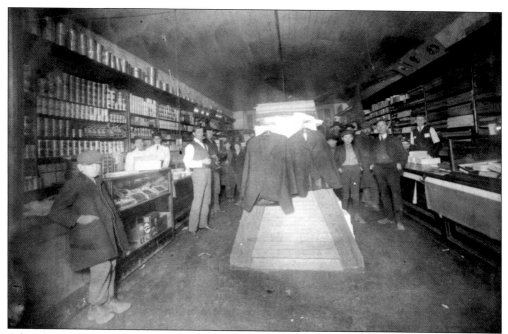

After the 1898 flood, Ed Bass and 19-year-old Claude Bass started Bass Mercantile. They worked out of this small wooden structure at the corner of Seminary and Main Streets until the fire of 1904. A year later, after rebuilding, Claude, who was known for his successful business skills, managed the business on his own.

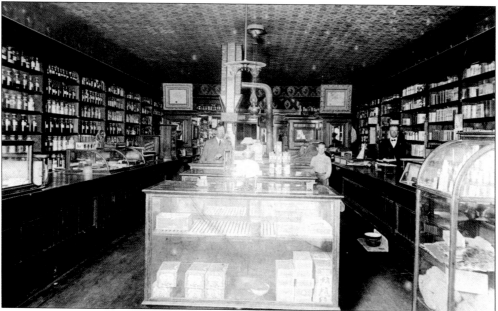

Alexander Gibson, a native of Harpers Ferry, Virginia, moved to Missouri to handle a brother-in-law's estate. After falling in love and marrying Haney Halbert of Franklin County, the couple settled in Steelville in 1855. The practicing doctor and druggist opened his own office and drugstore on Seminary Street, one block from Main Street. The couple's son, Thomas R. Gibson, would later open and manage the Gibson Hotel, which was located right beside his father's office.

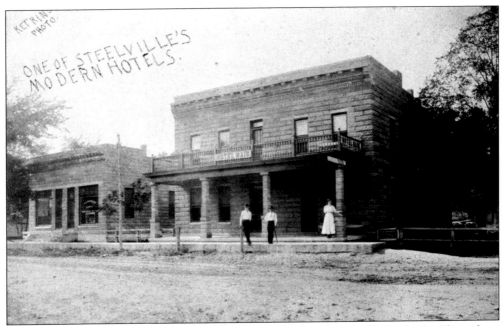

Showing the freshly placed sidewalks, this photograph was taken in 1910. The buildings from left to right are Earl Robert's law office and Hotel Main. The hotel offered lodging for visiting attorneys and had a bar and restaurant on the first floor.

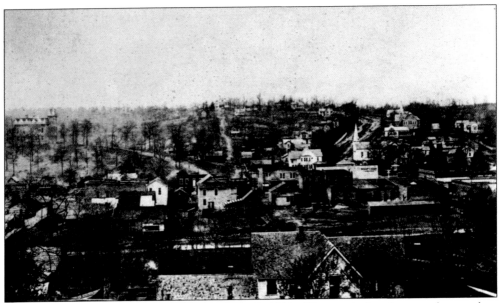

Bird's-eye view postcards were common in the early 1900s. This particular photograph was taken around 1906 from a hill south of town. On the back of the postcard, a girl by the name of Rosa wrote to G. H. Richards of Aaron, Illinois. She describes Steelville as "the large town we are in. I am afraid to go home in the dark." Steelville was then considered one of the largest cities in the area.

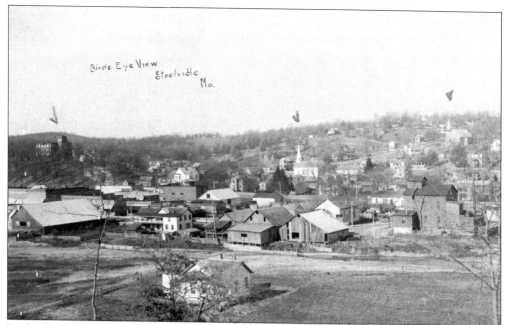

In this bird's-eye view, three points have been marked. From left to right, they are the Steelville Normal and Business Institute, Presbyterian Church, and Methodist Church. The building farthest to the right, in the front of the photograph, is the Steelville Roller Mill. Among the buildings along Main Street are various barns for storing the wagons and horses of the visitors at the multiple boarding houses.

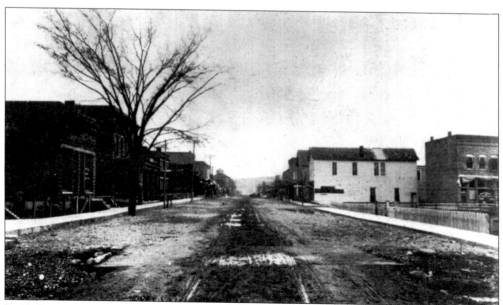

In 1912, Main Street was constructed of mud; however, sidewalks had been put in place. Looking east from where the Baptist Church stands, Earl Robert's law office is on the left, while William Lay's law office stood on the right of the street.

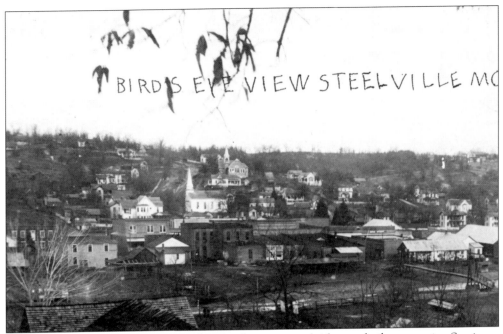

In order for pedestrians to cross the Yadkin Creek, a swinging bridge was built connecting Seminary Street on both sides of the creek. It is shown on the front right of this photograph.

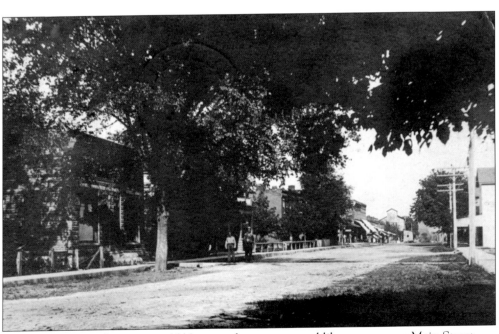

During the spring, the trees would bloom and create a tunnel-like canopy over Main Street.

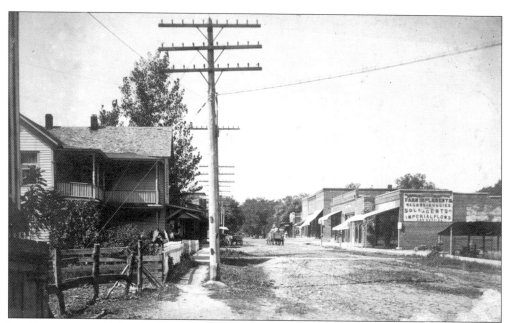

Looking west along Main Street, the Bouse House is located on the left. Behind the photographer would have been the Steelville Roller Mill. The wires in the photograph were connected to the mill's steam generator, which created electricity for the city until a water generator was built at Evan's Spring.

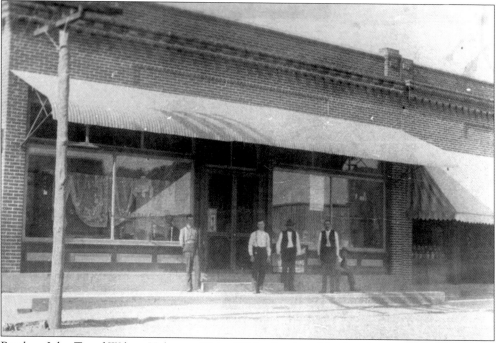

Brothers John T. and Wilson Haley established Haley Brothers Merchandise in 1905 on the corner of Seminar, which would later become First Street, and Main Street. Merchandise sold at the store included Carry Hamilton-Brown shoes, Kabo corsets, and Singer Brothers cloaks. Continuously keeping $8,000 to $10,000 in stock, the brothers reported annual sales of $25,000.

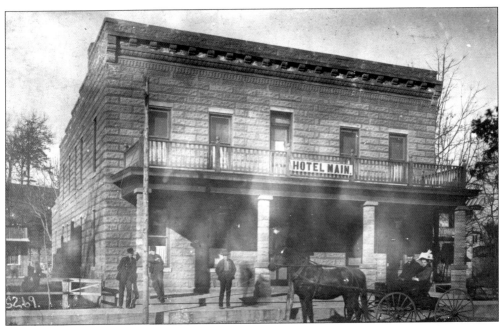

Hotel Main was completed in 1906 and faced the courthouse. The building offered 10 upstairs rooms and a bar and restaurant downstairs. Commonly found here were out-of-town attorneys, who were required to stay in Steelville for court. Hotel Main held the reputation as the "most modern hotel" of Steelville until the Rainbow Motel was built in the 1950s.

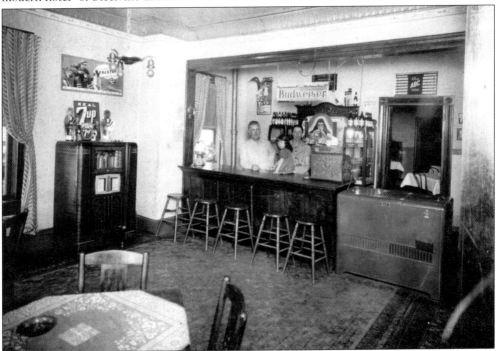

This photograph from around 1940 shows the inside of Hotel Main. Upon entering the building and turning left, one would find the office. During this period, owners placed a jukebox on the left wall and sectioned off the floor with a soda cooler near the right wall.

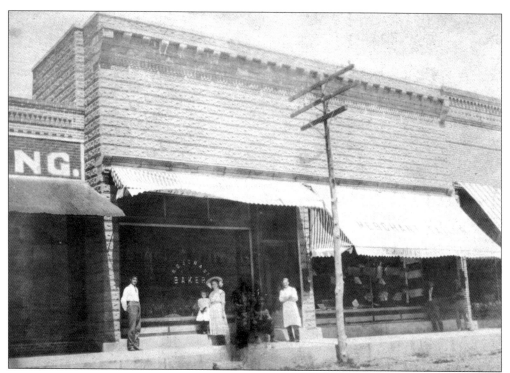

After marrying Rosa Lark in 1901, R. G. Jonas (left) bought out his partner John Bordas to obtain full ownership of Steelville Valley Bakery. Jonas moved the store in 1907 to the location pictured here with L. J. Jonas (right). R. G. Jonas continued the business until 1921, when he invested in grapes on the Jonas farm, which would become one the largest grape producers in Missouri. Later, in the early 1930s, Fritz Jonas, son of R. G. Jonas, would open the Jonas Drug Company in this very building.

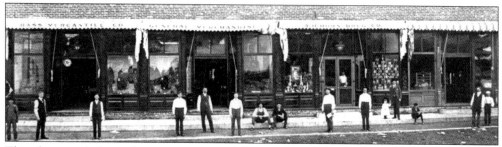

This photograph shows the new storefronts following the rebuilding after the fire of 1904. From left to right are Bass Mercantile General Merchandise, a drugstore, and what would become First National Bank in 1907. These stores stood along Main Street near the intersection of South Seminary and Main Streets.

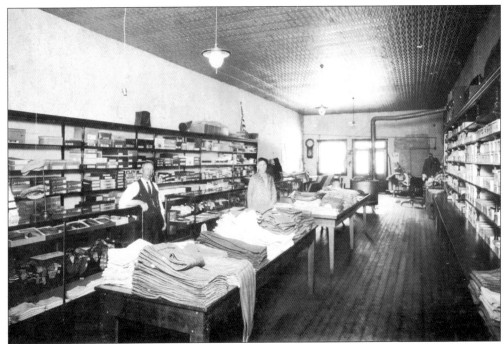

L. J. Jonas arrived in Steelville in 1895, and became the town's tailor and undertaker. The photograph shows his store after it was built in 1907. L. J. Jonas would eventually pass the store and position as undertaker to his son, Harry.

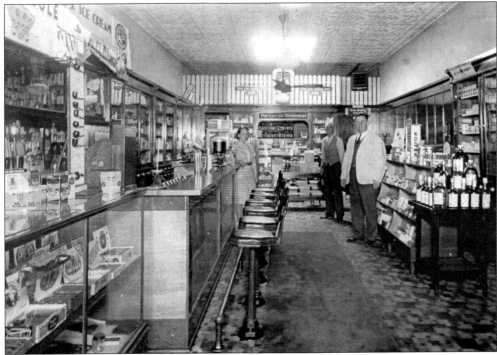

Arthur Schwieder replaced the Horn Drugstore, located in the Bass Mercantile Building, with his own drugstore in the 1930s. He owned and operated the business for approximately 20 years.

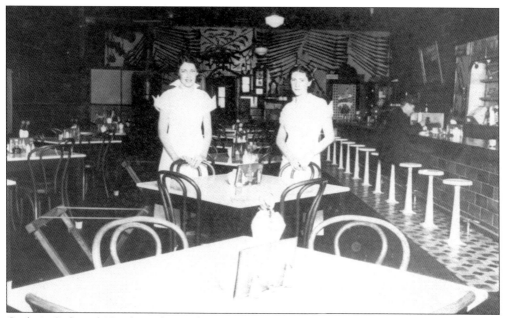

Curley's Cafe and Hotel was located near the southern intersection of Highways 8 and 19 in Steelville. Offering hotel rooms upstairs, the cafe and poolroom were downstairs. Curley's was known for the enormous Civil War gun collection that hung on the back wall. The building eventually burned down when the Robert Judson Lumber yard, located next door, caught fire in 1946. Pictured here are waitresses Ruth Payne and Ada Payne.

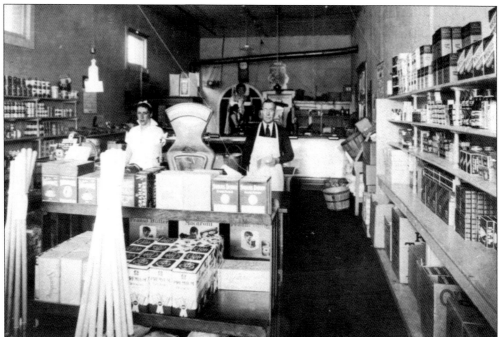

W. O. Key, the man in the photograph, owned and operated a grocery and meat market business out of the Haley Brothers Mercantile Building. His store was located on the northeast corner of Seminary and Main Streets. The young lady is Ruth Payne.

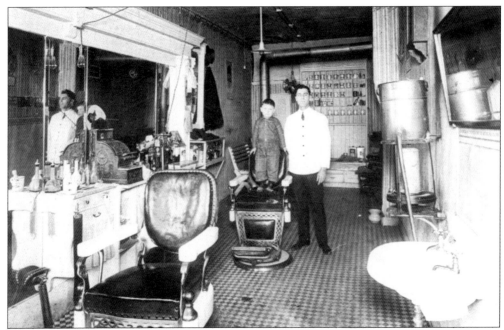

Alongside the Steelville Drugstore sat Steelville's Barbershop, run by G. T. Edwards. Edwards is shown in the photograph along with Dale Kimberlin as a child. George Pounds and eventually Skip Pounds later owned the shop. At this time, Edwards used a large candle to heat the tank of water needed in the shop.

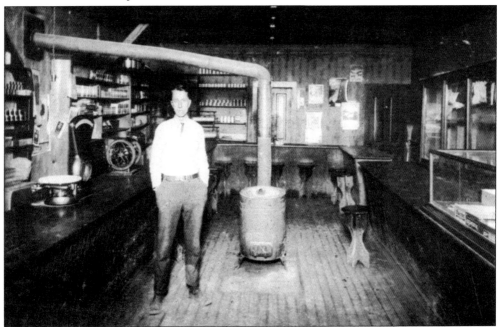

Boney Pounds, pictured here, ran his restaurant in the location that would later become the West End Tavern. It was rumored that Pounds never kept steaks on hand; when someone ordered a steak, he would run out the back door to Stough's meat market to purchase one. Pounds was also known for his jam pies, which were simply two crusts "jammed" together.

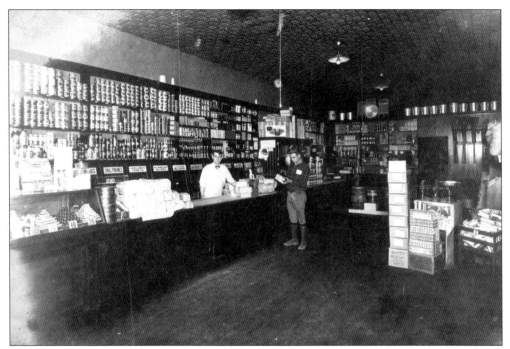

The Kroger Store opened during the 1940s and stayed in business until the mid-1950s. It was located in the A. J. Sanders Building, after A. J. Sanders moved to Chicago. At the beginning, Charles Macey operated the store. Management changed hands to George Fox by the time of the store's closure.

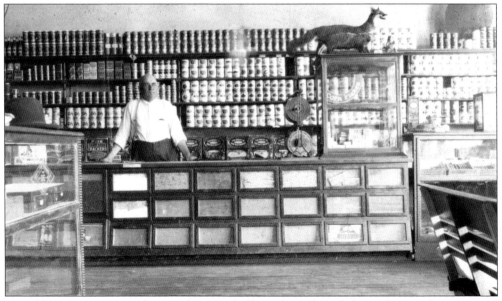

Donald McInnis, pictured, moved to Steelville and purchased the Haley Brothers General Merchandise Store in 1913. Using his business college education and experience obtained from his store in Huzzah, McInnis owned and operated the general merchandise store until 1934. His daughter, Hallie McInnis, opened Steelville's first beauty salon next door to the general merchandise store. His son Joy operated the Hotel Main.

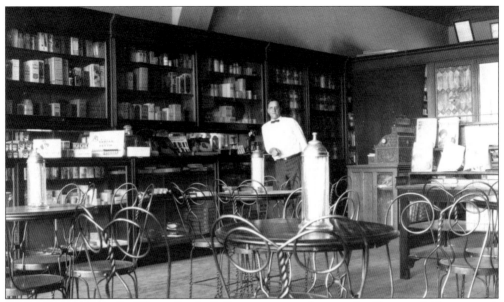

Originally founded by Dr. Wingo, Steelville Drugstore was taken over by Clarence Gibbs, pictured. Gibbs partnered with Dr. Barnard, and together they created a soda fountain in the store. Steelville Drug stayed in this building until 1988, when it changed locations. While at this location, it was the bus stop for decades and the place where many soldiers returned home.

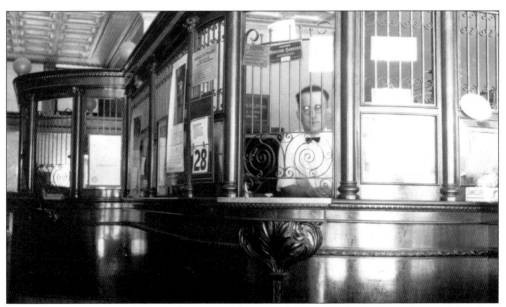

W. J. Underwood, president, and M. W. Lichius, cashier, started the First National Bank of Steelville on December 1, 1907. It was the only National Bank between St. Louis and Rolla and stayed in operation until the Depression. While open, the National Bank was the only Steelville bank able to print money due to being a National Bank. The bank clerk, pictured here, was Ralph Saltsman.

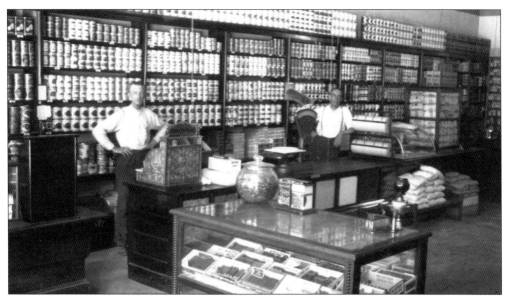

Bass Mercantile Company was owned by Claude Bass (right) in 1922. Bass was known for his large promotions. Included in the store's stock were millinery, coats, clothing, corsets, stoves, groceries, and much more. Bass Mercantile stayed in the grocery business until 1963, when the store was sold to Skip Wishon.

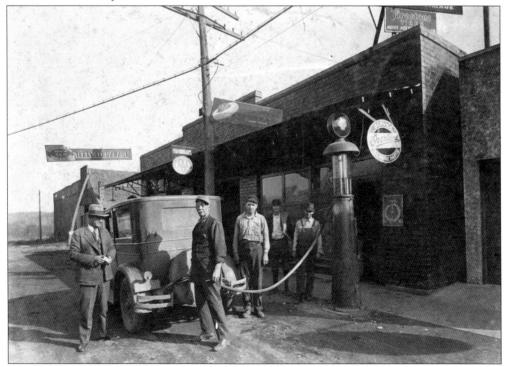

George F. Schwieder, pictured, was one of the three original creators of the Steelville Garage on July 1, 1918, which later became Schwieder Ford. His granddaughter, Sally Schwieder, explains how his outstanding service led to him becoming the fourth largest dealer for Overland and Willys-Knight cars, an achievement that earned him a medal from Willys-Knight in 1927.

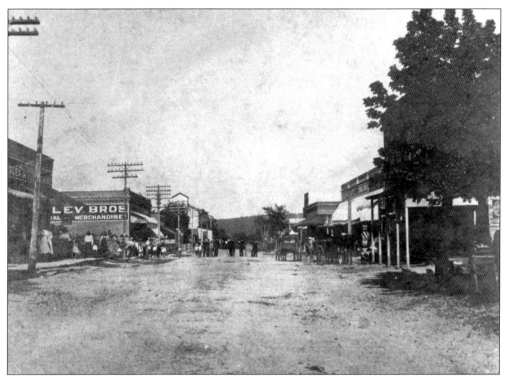

Taken between 1904 and 1908, this photograph shows a newly built Steelville after the fire. The Haley Brothers Merchandise sign is painted on the building on the left, while the mill can still be seen at the end of the road. In the center of the photograph is a marching band playing on Main Street.

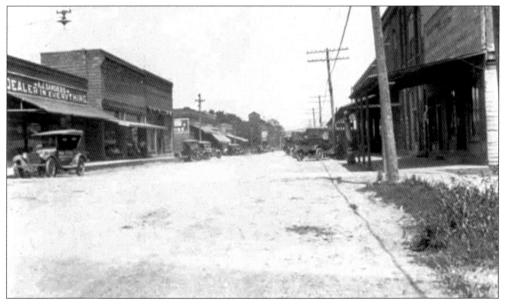

Herman Lark, a World War I soldier, returned home to work in the family telephone business. During this time, he sold Delco Home Electric Systems and became an amateur photographer. The next five photographs are part of his 1921 photograph collection of Steelville.

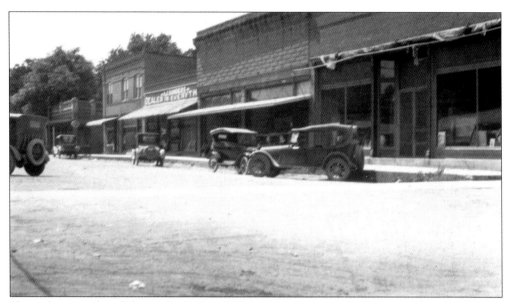

Shown here are, from left to right: Red and White, Grover Summer's Drugstore, Crawford County Farmers Bank, A. J. Sanders Dealer and Everything Store, Jonas Bakery, Jonas Tailor, and J. C. Lark's corner store.

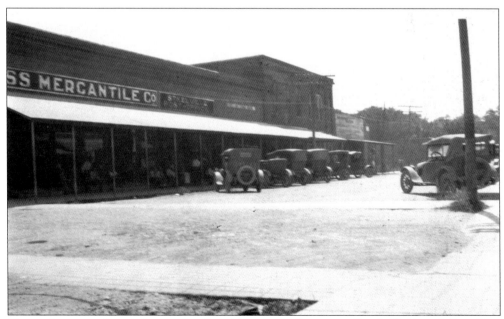

Shown here are, from left to right: Bass Mercantile Company, Steelville Post Office, First National Bank of Steelville, Harry Bass grocery store, Joe F. Baloun's Jewelry, and Boney Pound's restaurant.

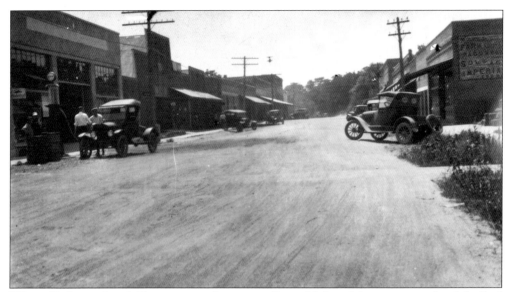

Where Highways 8 and 19 intersect today, originally sat Midway Motors, pictured at left. Fred Peetz operated this store. Across the street stood Scott's General Merchandise, at right.

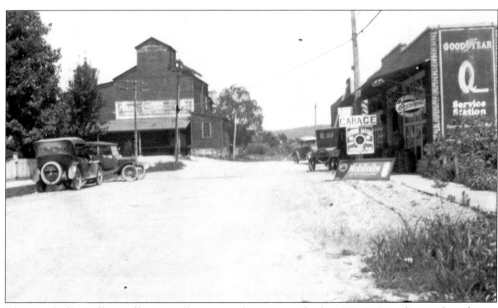

The Steelville Roller Mill originally operated in Riverside, but W. C. Devol transferred it to Steelville. Creating electricity from an old steam engine and generator, the mill produced flour that was sent to the surrounding areas.

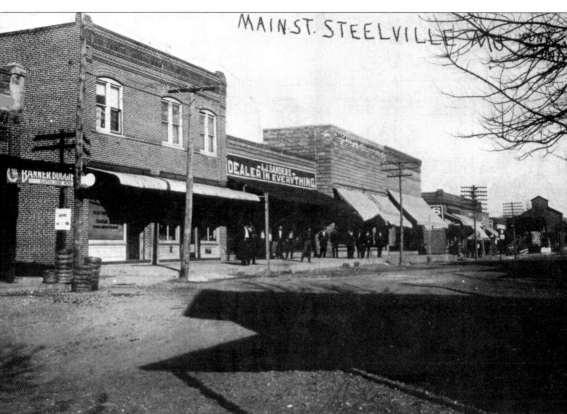

On March 26, 1925, five men came into Steelville expecting to rob one of the banks, but due to the bravery of the citizens, they were never able to meet their goal. While the five men drove from St. Louis, they stopped and robbed a restaurant in Sullivan. Word was quickly spread to Steelville's sheriff, Chris Enke, by the town's prosecuting attorney. The sheriff collected a group of 15 to 20 deputies and awaited the gang. On this morning, the five men—Lex, the leader; Basil Doman; Albert Walters; Leslie Reiter; and Dave McCellan—drove into Steelville. Reiter, who was only 16, was recently added to the group to reduce suspicion due to his age. He was used to investigate the bank, and upon returning to the car, the gang drove toward Cuba. They returned around 1:30 p.m., parking their vehicle in front of Clymer's house and releasing three members. These men entered Farmer's Bank and succeeded in taking $3,095. However, as soon as they attempted to enter into their stolen Studebaker, gunshots were fired. Albert Walters, the driver, was killed immediately. McCellan surrendered. Reiter attempted to escape but was caught without a weapon. Doman found himself in a shootout with A. D. Schwieder, who was wounded, and after attempting to escape was badly wounded himself and died 30 minutes later. The leader, Lex, was never found and appeared to have mysteriously escaped.

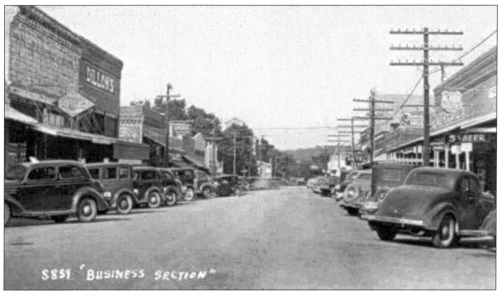

This photograph was taken in the late 1930s, looking east. Stores on the left include R. F. Jonas Drugstore and Dillons.

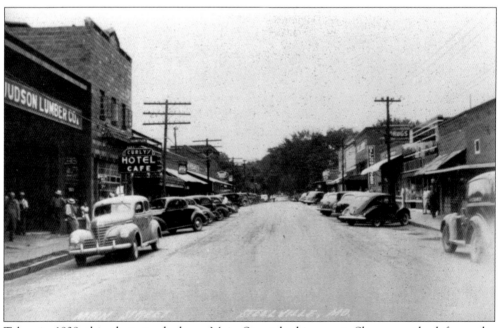

Taken in 1939, this photograph shows Main Street looking west. Shown on the left are the Robert-Judson Lumber Company and Curly's Hotel Cafe, which would burn down in 1946. The Gem Movie House, Jack Davis Furniture Store, and Steelville Drugstore are pictured from right to left.

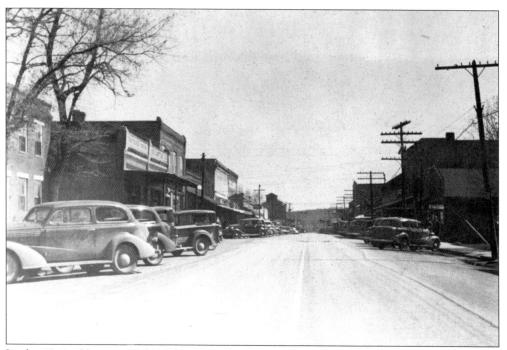

In the 1940s, Herman Lark took a second collection of Steelville photographs. The next six photographs are included in this set. This photograph was taken standing in front of the courthouse, looking east. On the left stood the Eugene Trask house and the Farmer's Union. On the right is the West End Tavern.

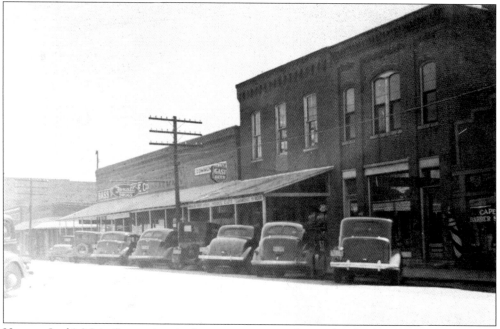

Herman Lark's Main Street view, looking east, captures the south side of Main Street with, from left to right, Bass Mercantile, Schwieder Drug Store, Community Bank, Baloun Jewelry, and Cape Barber Shop.

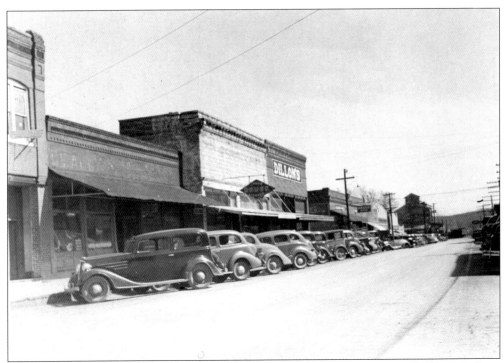

From left to right are Kroger Grocery, Fritz Jonas Drug Store, Harry Jonas Clothing, Dillons Grocery, D. McInnis, Steelville Drug, and Jack Davis Furniture Store.

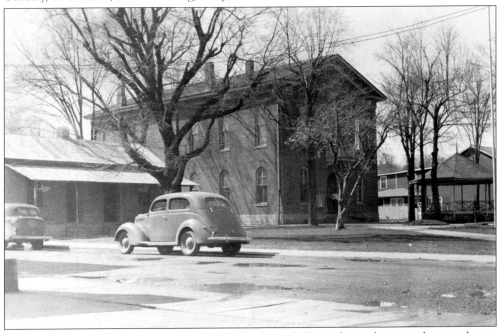

The magistrate and probate judge's office court building (left) was located next to the courthouse in a little red brick building. The courthouse was built in 1874 after the original 1857 courthouse burned down. On the far right was a bandstand, which was where politicians would give speeches while traveling through Steelville.

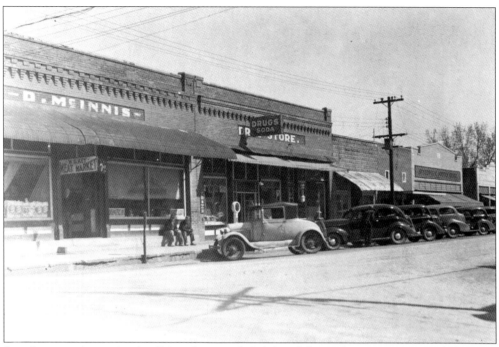

Storefronts on the north side of Main Street included, from left to right: D. McInnis, Steelville Drug, T. Edward Barbershop, Jack Davis Furniture Store, Gem Movie House, and Steelville Supply.

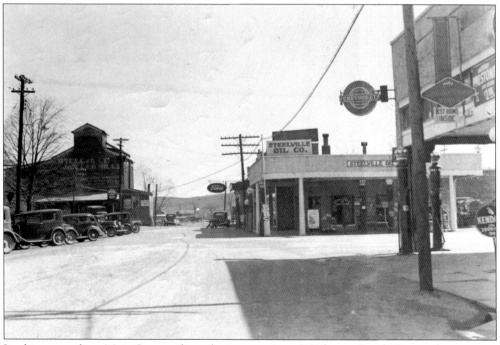

Looking east along Main Street, where the intersection of Highways 8 and 19 are today, one can easily see the Steelville Roller Mill on the left. Along the right, from right to left, are Midway Motors, a business known as "Steelville Oil Company," and Schwieder Ford.

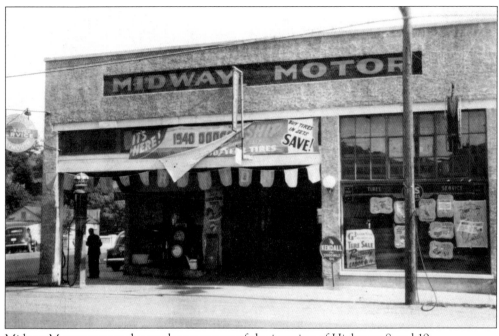

Midway Motors was on the southwest corner of the junction of Highways 8 and 19.

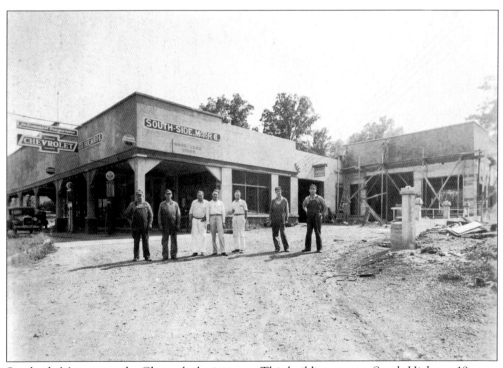

Southside Motors was the Chevy dealer in town. This building was on South Highway 19.

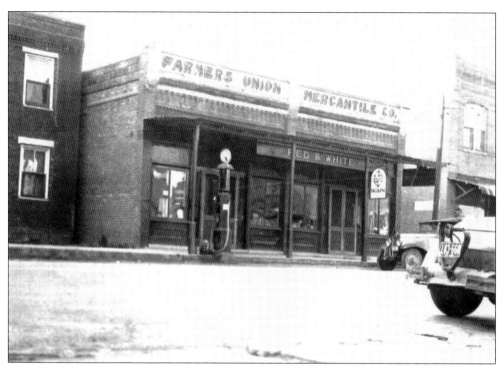

Located at the corner of Main and North College Street was the Farmers Union and Mercantile Company, later known as Red and White.

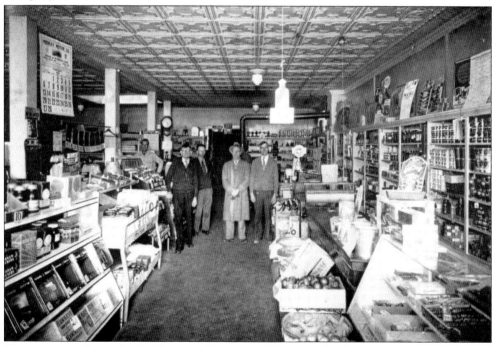

Those pictured inside the Farmers Union and Mercantile Company are, from left to right, Don Gravatt, J. M. Cape (manager), E. M. Saltsman (bookkeeper), an unidentified customer, and C. L. Perkins.

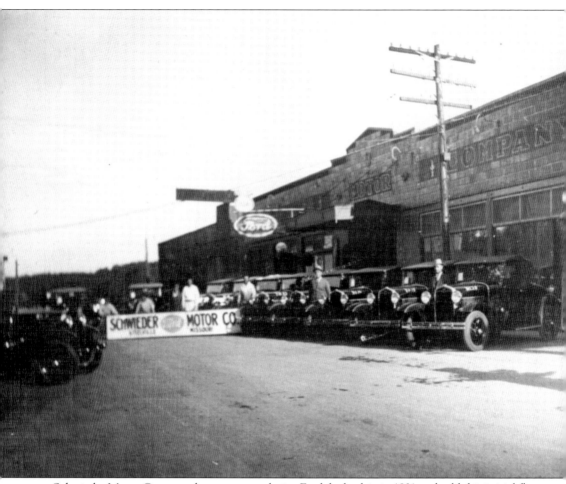

Schwieder Motor Company became an exclusive Ford dealership in 1931 and sold this initial fleet of 42 highway patrol cars to the state of Missouri. There were not enough plates for the fleet, so Schwieder painted car numbers on the hood and called them "somewhat legal" to drive to Jefferson City. Boys from the high school, many without driver's licenses, were given the day off to deliver these cars and see the capitol. George Schwieder had constructed the original building in 1918 and founded the company, which sold several brands of autos throughout the 1920s. Banks were ordered closed in 1933, and the company opened the next day with only $15 left in the cash register but somehow persevered. The name became Schwieder Ford in 1940, and upon the death of George, his sons Ed and Latham operated the business. In 1976, Latham's interest was purchased by Ed's son Kem, and in 1986, Kem purchased Ed's interest. The dealership operated in the same location until Kem retired the franchise in 2006, thus ending the era of new car dealerships in Steelville.

Four

HOME SWEET HOME

Houses were more than just a place to live. They were homes to those who lived in them, and many took pride in their residences. The owner's own hands and resources built some, while others were ordered through Sears and delivered via trains. Either way, houses can tell a lot about how past Steelvillians lived. This house was the home of Thomas and Emma Everson and stood west of downtown Main Street. The photograph was taken on June 3, 1897, and the house continued to stand until a massive flood in 1898, when the newspaper wrote, "no language can suitably describe the condition of the dwellings."

Charles Everson, son of Thomas H. Everson, photographed his house with his family in 1897, just one year before the flood of 1898 destroyed his house. From left to right are Emma (Everson) England, Mrs. Charles O. Everson, Walter England (child), Tom England, Wayne England, Charles O. Everson, and Sarah A. Farrow.

This house still stands at 206 South Spring Street. It faces Hoppe's Spring.

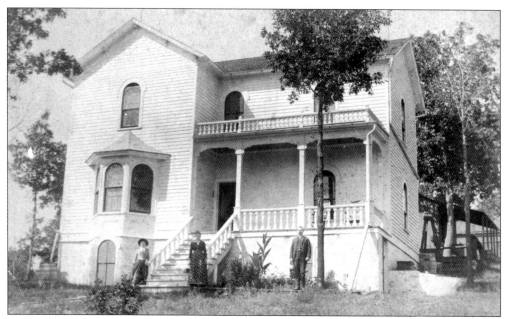

Located on East High Street, this was the home of Missouri senator and representative Frank Farris. A wounded Union Civil War veteran of the great battles of Shiloh, Vicksburg, Missionary Ridge, New Hope Church, and the march to Atlanta with General Sherman, Farris was considered an eloquent, spellbinding orator and was also considered a very controversial politician, later known as "Frisco Frank."

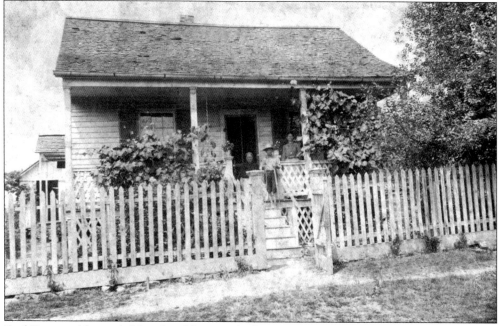

Fred Peetz and his wife Mary lived here at the beginning of the 20th century. Fred Peetz was employed in the tie and timber industry, which was a very time consuming and taxing line of work. This was lonely for Mary, and she began to raise chickens around the house to occupy her time. This resulted in a successful business, bringing in $375 the first year.

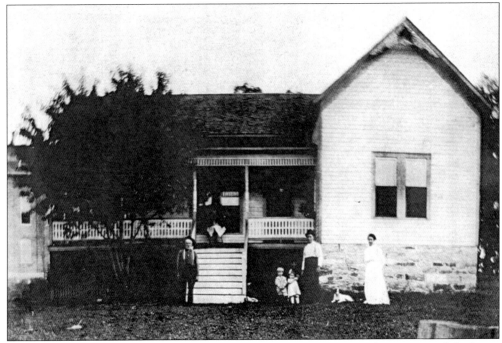

The home of Andy Schwieder was built on West High Street. Schwieder was one of the brave men who assisted Sheriff Chris Enke during Steelville's great bank robbery on March 20, 1925. During the robbery, Schwieder received a bullet in his leg.

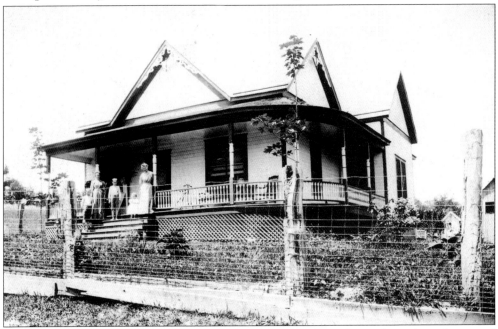

In 1906, Tom and Fannie Saltsman built their home at 204 Spring Street. It was here they raised their three children Claud, Ralph, and Grace, pictured here with their mother and Annie Metcalf Saltman, Tom Saltsman's mother. Kermit Carr and his wife Eleanor Boas Carr later purchased the house in 1962, and it remained in the Carr family until 2000.

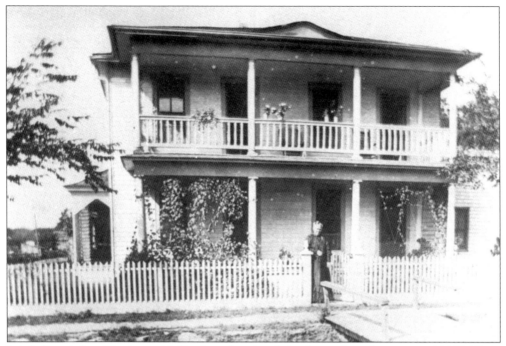

It is believed that Charles and Lillie Stough ordered this house from Sears around 1908. Their home arrived by train in pieces and was assembled at 102 North Seminary Street, next to the railroad tracks.

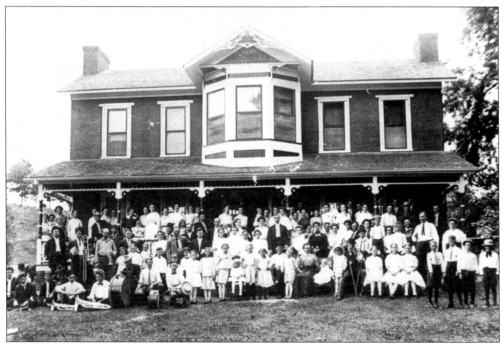

John Clinton lived in this home on Euclid Avenue west of Steelville. The reason for the photograph was an ice cream social held around 1900. Clinton's son Elmer was one of the band members on the left.

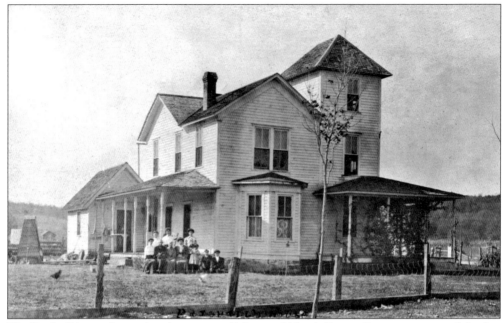

The Parshall home, located at the corner of Main and North Spring Streets, was one of the few homes that only experienced minimal damage after the flood of 1898. The Parshalls housed Professor Chapmen, a teacher of the Steelville Normal and Business Institute, while he taught for the college.

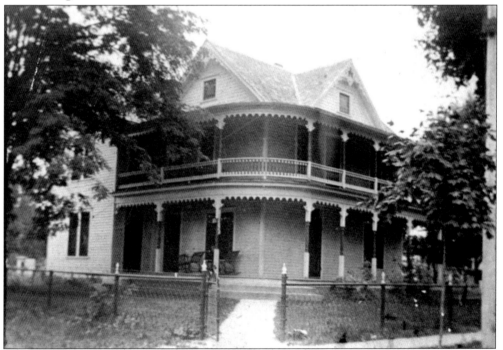

Donald McInnis constructed his home at the corner of Keysville Hill Road and Main Street around 1912. He and his wife Effie Clonts McInnis lived here and passed the house down to their daughter Hallie McInnis. In 1979, the house was torn down to build the Community Bank.

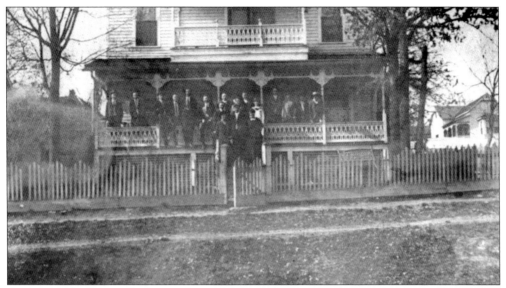

On East High Street is the home of A. J. Sanders, which was built around 1890. Sanders was the owner of the A. J. Sanders Dealer of Everything Store on Main Street. His granddaughter Nedra was voted the "Most Beautiful Brunette in the World" in *Life Magazine*'s March 1941 edition. After receiving the award, Nedra modeled for Coca-Cola and became the only person to model for more than one Coca-Cola tray.

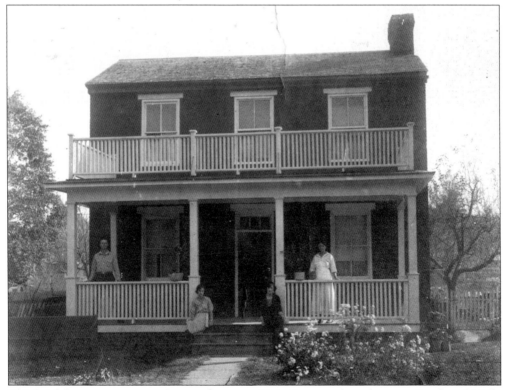

This brick house was next to the courthouse on Main Street and was home to Frank and Molly Nethington. It was later torn down in order for the Baptist Church to build its parking lot.

William Lay, a wealthy attorney, lived in this house in the early 1900s. Lay was also a successful businessman, starting Lay Abstract Company in 1904. The site of the Lay house has seen many changes since Lay lived there. It was torn down to build Earl's Chevrolet Building, which later became a hotel and music hall.

The Bass house, located at the corner of First and High Streets, has seen multiple additions and renovations throughout the years. I. P. Brickey built the original two-story house in the 1860s. Later an L-shaped addition was added, and in 1911, Claude Bass remodeled the house to the condition it is in today.

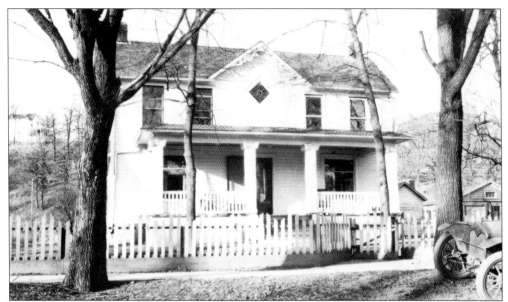

The home pictured above was built on Main Street and continues to stand today. Originally built for the Marsh family, it would later become the home of R. F. Jonas. Today the house is known as the Jonas Museum and holds artifacts of Steelville's history.

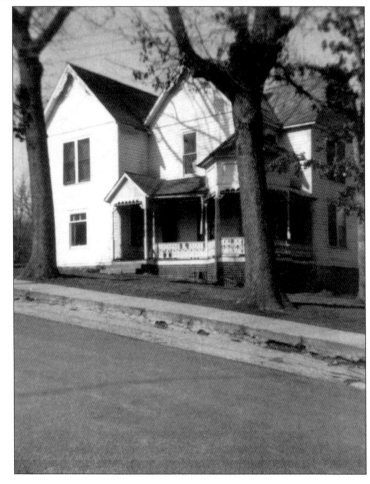

The W. L. Wingo house was located on West High Street.

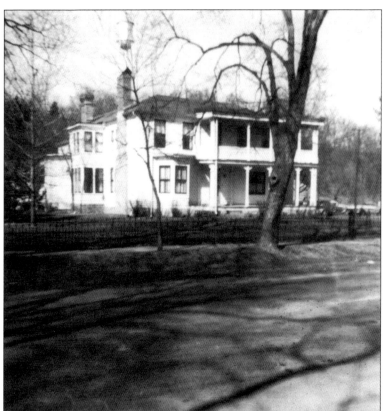

W. C. Devol constructed this new house prior to 1898 on Main Street. It remained standing until the early 1970s, when it mysteriously burned to the ground. The cause of the fire was never found, and many rumors spread about its origin.

The grand home of attorney Harry Clymer stood at the corner of Seminary and Frisco Streets. It was later torn down to build Presbyterian Church's parking lot.

Five

CHILD'S PLAY

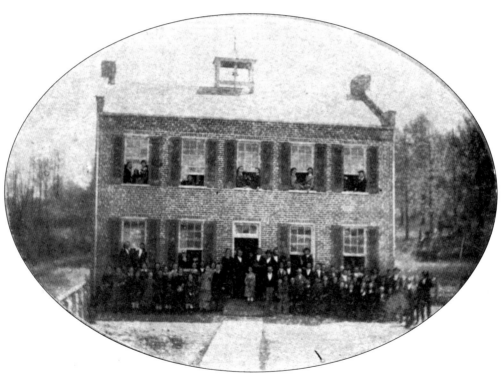

Steelville has seen multiple schools throughout the decades. From the first, a private school, to a college, Steelville's schools have helped form the town. In the 1880s, Steelville was criticized for its poor education, and the citizens moved to change that. This brought Steelville Normal and Business Institute into the town and increased funding to the public school system. But before the public school system was formed, St. Louis Presbytery of the Cumberland Presbyterian Church formed the Steelville Academy, pictured. The building was constructed at a cost of $2,000 in 1858. The Academy stayed in existence until 1880, when the building was sold to the public school district.

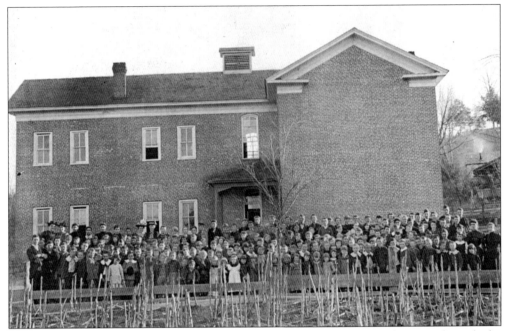

Upon purchasing the Academy Building, Steelville's school district raised money through the sale of 20-year bonds to reconstruct the building. Plans included tearing down and rebuilding the second floor, while remodeling the first. The result is shown here, with the windows filled in with bricks. The financing needed for the reconstruction amounted to $3,000.

The school was placed at the corner of Seminary Street and Keysville Road. The back of the building faced Keysville Road.

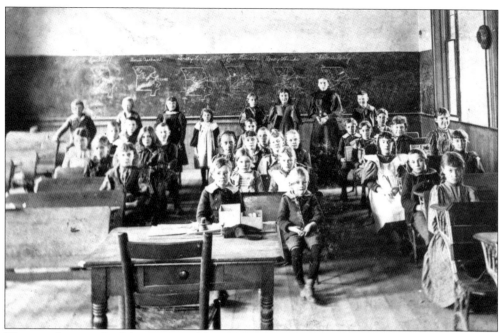

This is a photograph of the interior of the old Steelville Academy in 1894. The teacher was Belle March, and while most of the students are unknown, Lucy Haley is three students left of the teacher. Haley furthered her education at Steelville Normal and Business Institute and became a teacher herself.

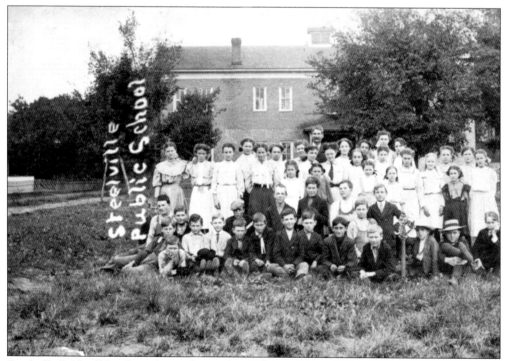

Steelville Public School was located near the Yadkin Creek. This photograph shows the wall of the building facing the creek with the students outside, photographed around 1904.

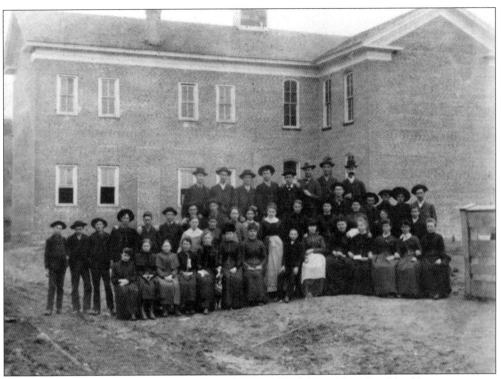

Taken around 1900, this photograph shows the outside of the public school building.

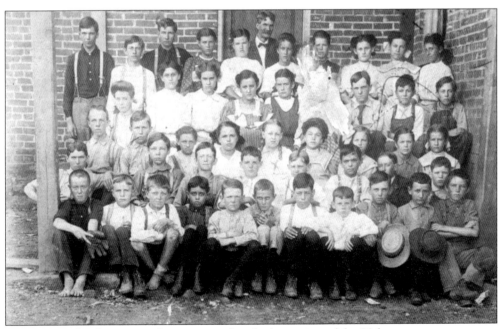

J. S. Fitzpatrick's elementary class is pictured at the beginning of the 20th century.

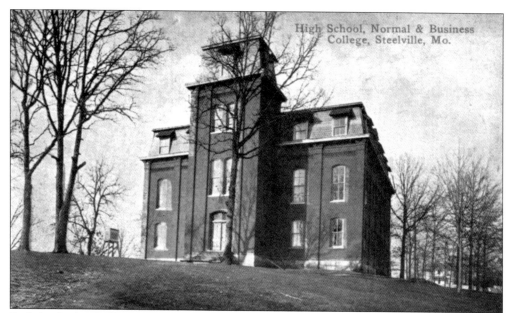

High School, Normal & Business
College, Steelville, Mo.

Built for the Steelville Normal and Business Institute (SN&BI), this building was finished in 1890. That fall SN&BI opened its doors to the first class. The institute had originated in Vichy, Missouri, but it was decided to move it to Steelville. The school offered education in "the classics and education." Some of the graduates went on to become doctors, lawyers, judges, and senators.

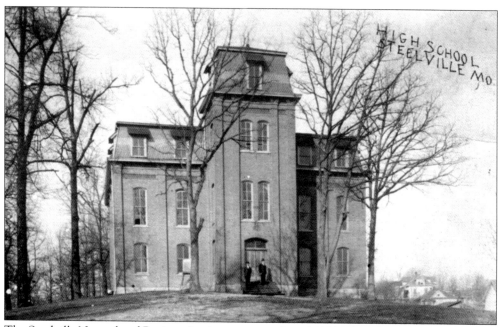

The Steelville Normal and Business Institute remained until 1903, when financial troubles forced the school to merge with the public school system. Between 1903 and approximately 1915, SN&BI merged with the Steelville High School. SN&BI eventually failed and the public high school stayed in the building until it was torn down in 1925.

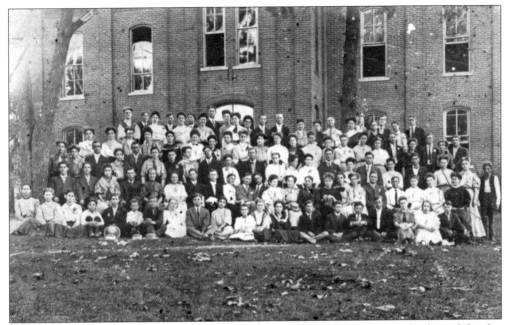

Taken in front of Steelville High School, this picture shows the student body and faculty around 1910.

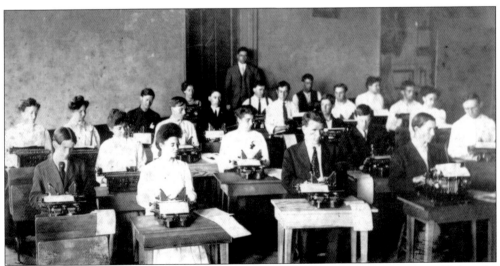

One of the students in the Steelville High School Business class of 1908 was Lucy Haley, the young lady in the front row. This is one of the few photographs taken inside the original SN&BI Building. Haley would later become a teacher for Steelville schools.

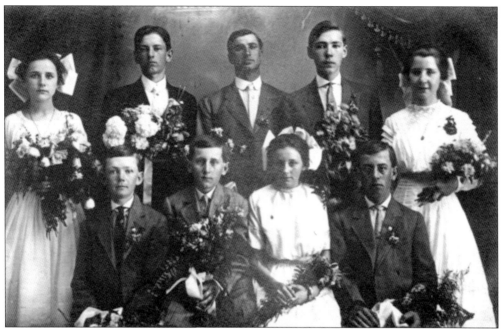

Seen here is the graduating class of 1910–1911 at Steelville Elementary. From left to right are (first row) John Emery Clinton, T. R. Saltsman, Hazel Stough, and C. S. Saltsman; (second row) Susie Walker, Corbett Leezy, Albert Kreamalmyer, Bernie Grubb, and Amy Williams.

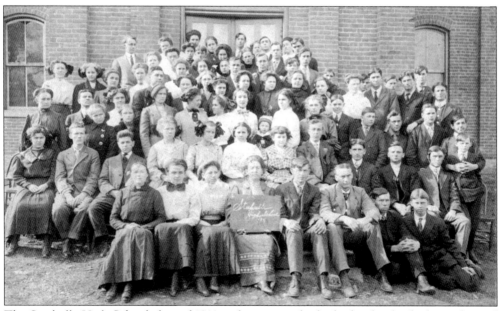

The Steelville High School class of 1911 is shown outside the high school, which was located on College Hill.

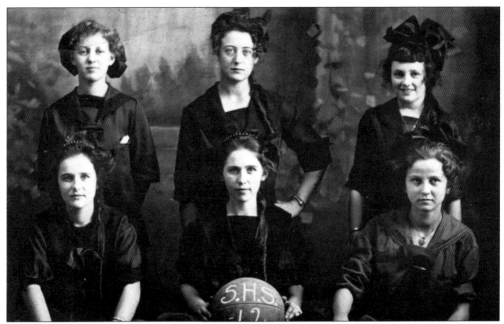

Here are members of the Steelville High School girls' basketball team in 1912. From left to right are (first row) Susie Walker, Virginia Walker, and Blanch Roberts; (second row) Marjorie Scott, Irilla Porterfield, and Hazel Stough.

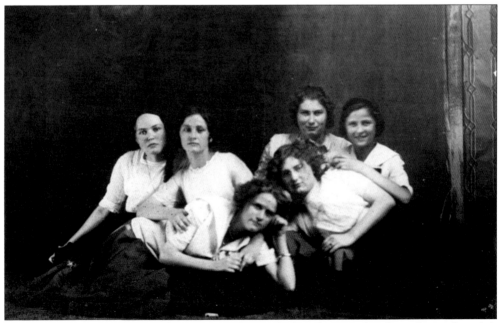

On May 14, 1912, members of the Davis Borders took this photograph. The girls are, from left to right, (first row) Elsie Martin and Minnie Stukenbroker; (second row) Marie Colvin, Mabel Roberts, Mabel Stukenbroker, and Blanche Roberts.

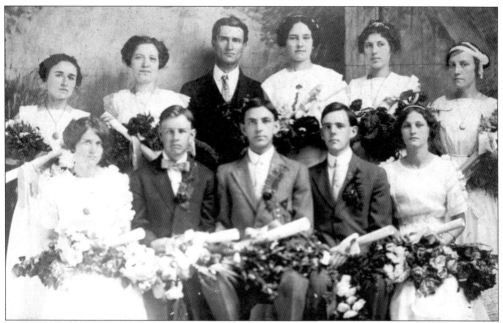

The members of Steelville High School's graduating class of 1913 are, from left to right, (first row) Elsie Martin, Claude Midgett, Bert Grubb, Joel Mason, and Mabel Roberts; (second row) Sara Walker, Zelma Leezy, Professor Chapman, Mary Crawder, Anna Oberkrom, and Haney Housewright.

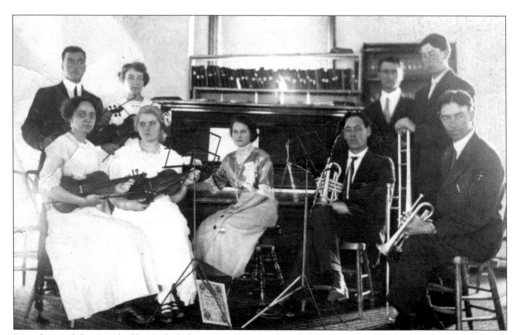

Members of the Steelville High School Orchestra of 1911–1912 are, from left to right, John Cores, Empo Norwell, Dema Houston, Minnie Cole, Geneva Whitemire (piano), Roy Clymer (trumpet), Carl Norwell (trumpet), Professor William Chapman, and Glover Summers (trombone).

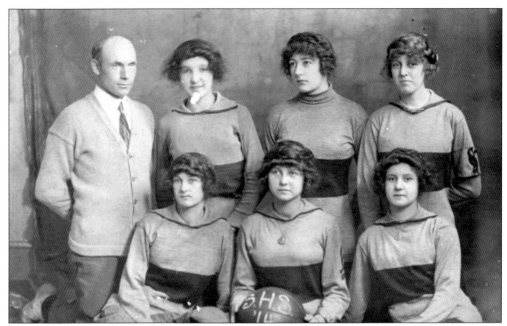

Steelville High School's girls' basketball team in 1914 included, from left to right, (first row) Mabel Roberts, Blanche Roberts, and Hallie McInnis; (second row) Coach N. E. Winfrey, Irene Grubb, Irilla Porterfield, and Marjorie Scott.

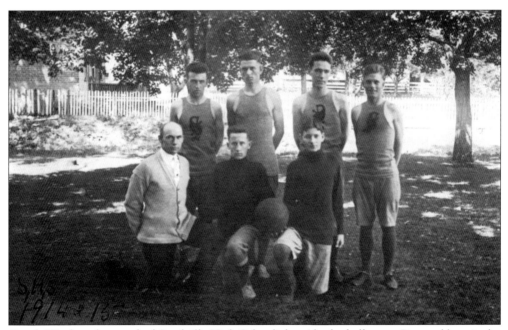

Coach Winfrey also coached Steelville High School's boys' basketball team. Pictured here is the 1914 team; however, names were not included.

Coach Winfrey stayed with Steelville High School for several years. This picture shows his boys' basketball team during the latter portion of the first decade of the 20th century.

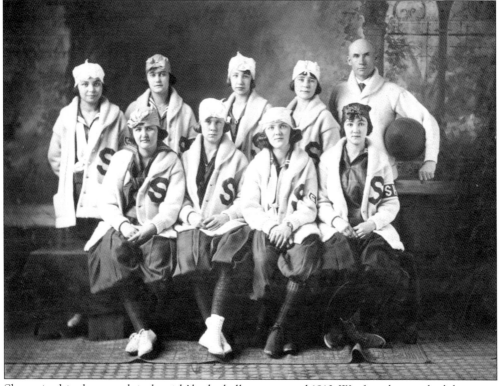

Shown in this photograph is the girls' basketball team around 1910. Winfrey also coached this team.

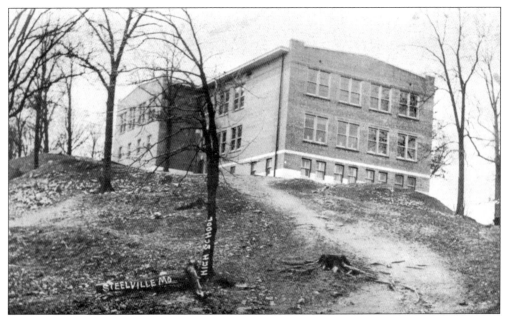

In 1924, Steelville public schools decided to tear down the old Steelville Normal and Business Institute and rebuild the high school and grade school on the same hill. This was the first time that both the high school and grade school were housed in the same building.

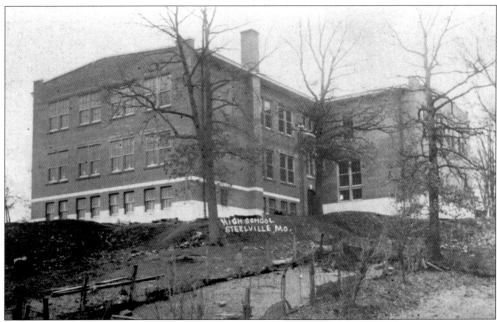

After completion, classes started in January 1925. In the 1930s, as a PTA project, stone walls and steps leading up to the school were added. A fire destroyed the building on April 11, 1937.

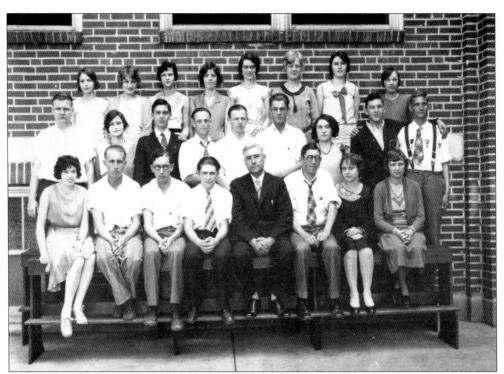

Steelville High School's graduating class of 1930 is pictured in front of the school.

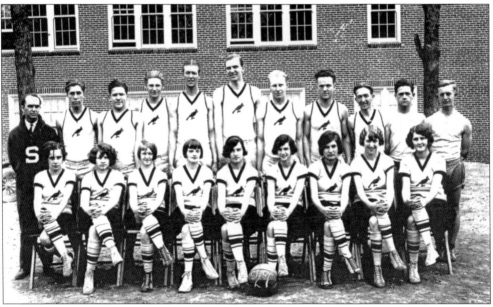

Seen here in front of the newly constructed public high school are the 1927 boys' and girls' basketball teams for Steelville High School. Pictured are, from left to right, (first row) Carmen Scott, Rowena Bass, Hazel Lichius, Edna Dulaney, Nellie Hedley, Pauline Clymer, Elva Tomkins, Mabel Eaton, and Lucille Blunt; (second row) Coach P. D. Wingo, Emil Smith, Roland Bass, R. F. Jonas, Gordon Shoop, Raymond Parker, Earl Saltsman, Ralph Dulaney, Bill Cook, F. J. Lichius, and Harry Cook.

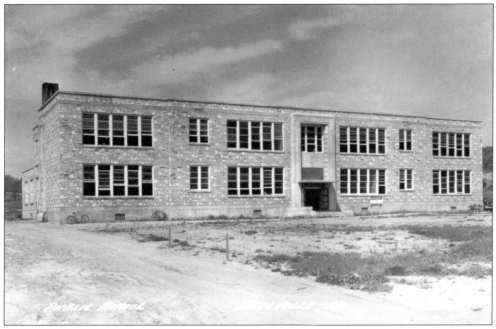

After receiving government funds under a WPA program, Steelville built a new school northwest of the town. Completed in 1938, the new school building served both high school and grade school students.

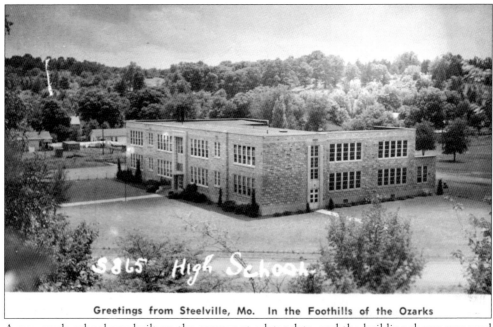

Greetings from Steelville, Mo. In the Foothills of the Ozarks

A new grade school was built on the campus at a later date, and the building shown was used as a high school until 1975, when the town constructed a new high school south of town. Later Steelville would use this building as a middle school.

Six

THE WAYS OF LIFE

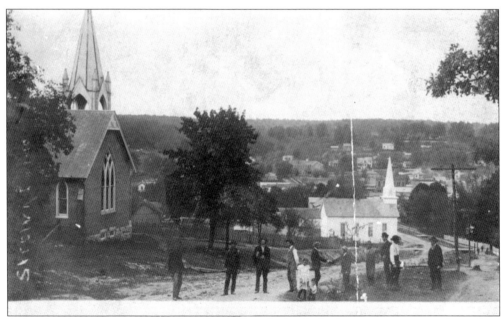

Before the advancement of technology, Steelvillians had to find other ways to entertain themselves. This was achieved through participation in clubs and simply enjoying the company of friends during a picnic. Steelville also experienced traveling entertainment, which was always an enjoyment. But of all the social aspects of life, church was a strong part. Steelville's Methodist church (left) and Presbyterian church (right) were located on Seminary Street. Seminary was known as Cuba Hill for it was the road connecting Steelville with Cuba. Alongside the Methodist church was the Bass Cemetery, where many Steelvillians were laid to rest.

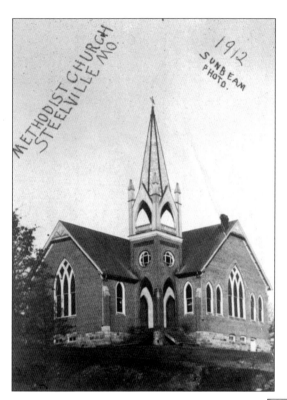

After changing locations multiple times, the First Methodist Episcopal Church was built in 1896 along Seminary Road. Constructed of brick, the building was described as a "right nice church." A few years later, on August 9, 1925, the church's tower was struck by lighting, starting a fire. Citizens saved most of the furniture inside, but the church was not able to be saved.

Rev. John E. Braley organized the Cumberland Presbyterian Church around 1845. He held services in the courthouse until moving to the academy building in 1858 and then to the Masonic Hall in 1868. Aiming to have its own building, the Presbyterian church was finally built in 1874 at the corner of Seminary and High Streets at a cost of $2,500. By 1883 the church had organized its own Sunday school, and by 1888 the congregation had reached 88 members.

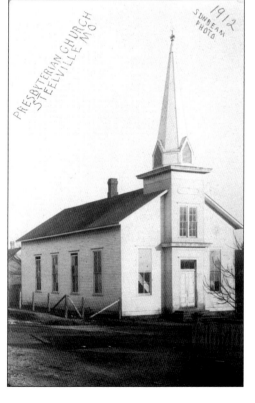

By 1925, the Presbyterian Church had been rebuilt. But this building did not last long. In 1957, the church was struck by lighting and burned, which forced the congregation to meet in an old gun factory until they were able to rebuild in 1964.

Only one year after Steelville was founded, the Baptist Church was organized in 1836. However, due to lack of accommodations, the church was moved outside the town. Then in 1856, Rev. E. R. Fort started making trips into Steelville congregating with citizens in homes until 1874. In this year, a large donation was made to the organization and paired with money earned from fundraisers, helping raise $1,200 to build a church. The original church was eventually torn down and the Baptist Church that stands today was built in 1914 along Main Street.

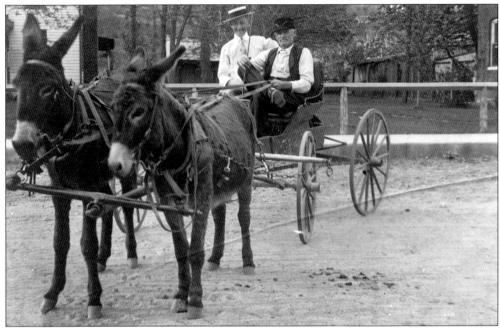

Ray Stough (left) and his uncle Sion Stough (right) were photographed on May 10, 1907, riding along Main Street.

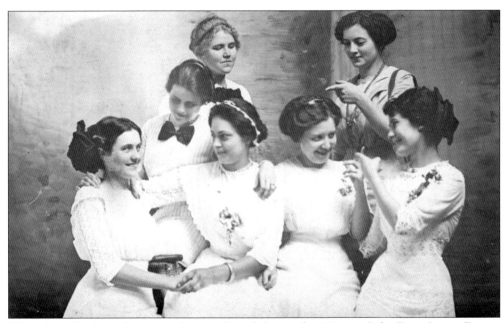

These formally dressed young ladies are, from left to right, Minnie Cole, Erma Leezy, Eunice Drunen, Marde Baldwin, Docia Clinton, Zelma Leezy, and Ethal Dorons.

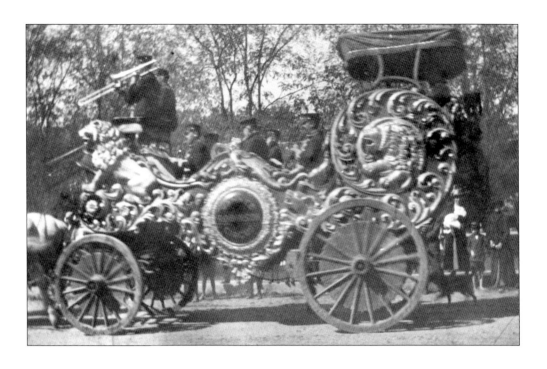

Around 1920, a traveling circus passed through Steelville. This parade, which included a band in an ornate carriage along with elephants and camels, is shown marching down Main Street.

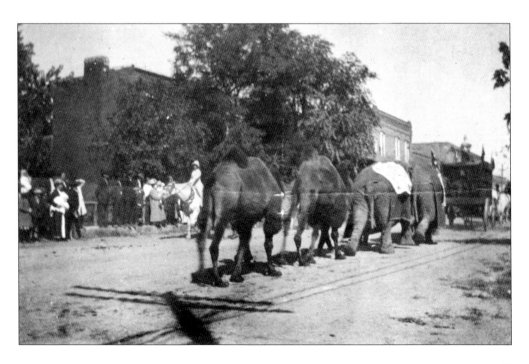

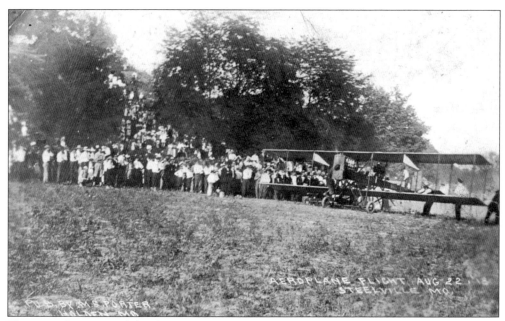

The annual meeting of the Yeoman District Association was believed to be one of the largest events of the year. The sixth annual meeting was held in Steelville on August 21–23, 1913, and over 15,000 people were expected to arrive. For the event, the committee had arranged an "aeroplane" flight at a cost of $500.

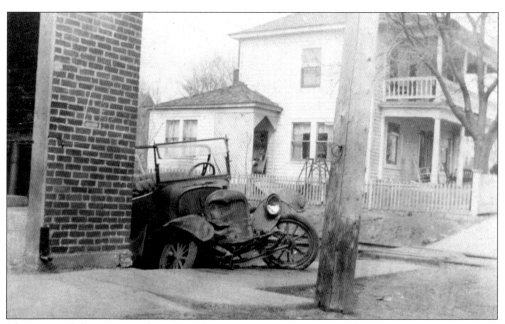

This automobile appears to have been hit by an oncoming train and thrown into P. D. Cooper's Lumber Company along Seminary Street. This location was known as Cooper Crossing and saw many similar accidents.

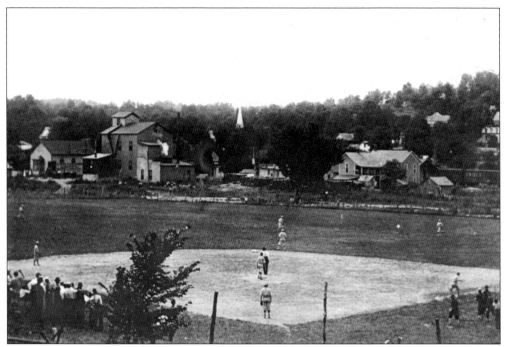

In the first decade of the 20th century, Steelville had its own semipro baseball team, along with its own ball field. The team was coached by R. G. Jonas and traveled from town to town to play games. Their home field was behind the Steelville Roller Mill, on the east side of town.

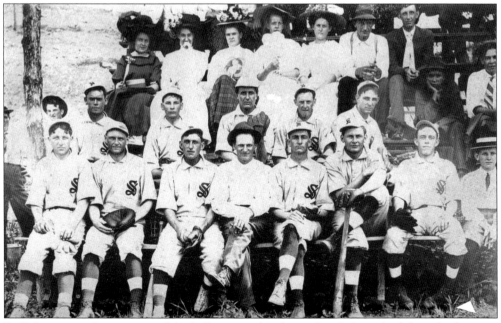

R. G. Jonas was the manager of the ball team and is shown fourth from the left in the first row. Other team members included Booge Upchurch, Rolla Creek, Cliff Marsh, George Schweider, Herman Lark, and Andy Schweider.

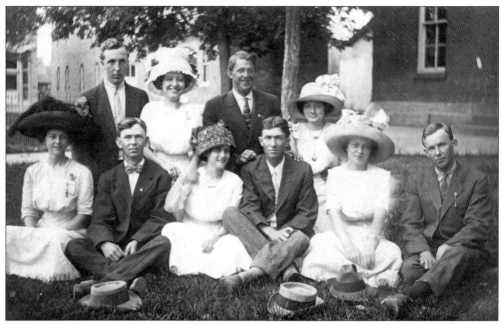

Sitting under the "old maple tree" on the courthouse lawn are, from left to right, Elias Gravatt, Zelma Leezy, Harry Kreamalmeyer, Erma Leezy, Unknown, Elmer Clinton, Maude Baulding, Noah Leezy, Docia Clinton, and D. M. Kreamalmeyer.

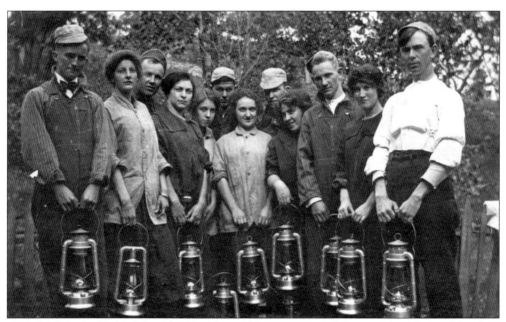

Described on the back of this photograph as "the gang stranded at Onondaga Cave when their hack broke down," are, from left to right, Bill Haley, Lola Schweider, Dan Clinton, Docia Clinton, Jewel Sanders, unknown, Daisy Dulaney, Fred Hughes, Mary Britt, A. D. Schwieder, Anna Provines, and Elmer Clinton.

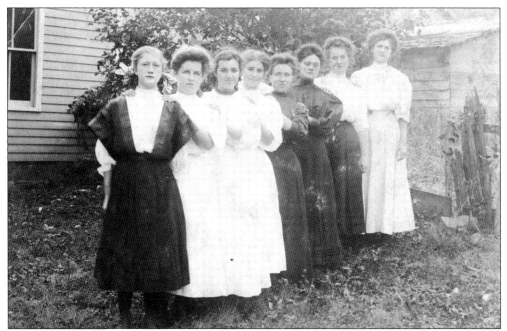

This group of ladies includes, from left to right, Gladine Peetz, Beryl Hamilton, Adell Hamilton, Vesta Mincer, Ruth Edwards, Lana Peetz, unidentified, and Louise Peetz.

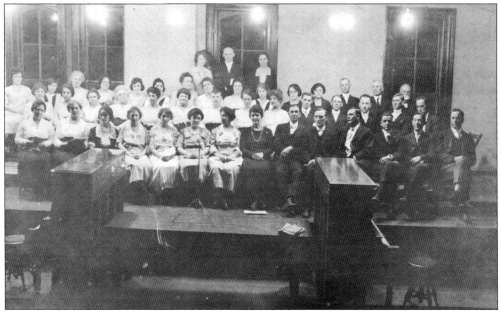

In May 1921, the Steelville Choral Society held its last performance in the old Steelville Normal and Business Institute, which was at the time the public high school. Members of the society included many prominent members of the community such as W. J. Underwood, Joe Baloun, Dr. Wilson, Ray Parker, Geraldine Coffee, Rose Shoop, Roy Clymer, Mrs. Devol, Anna and Ashley Harrison, Eula Baloun, Dr. Harry Parker, Professor Winfrey, and Hallie McInnis.

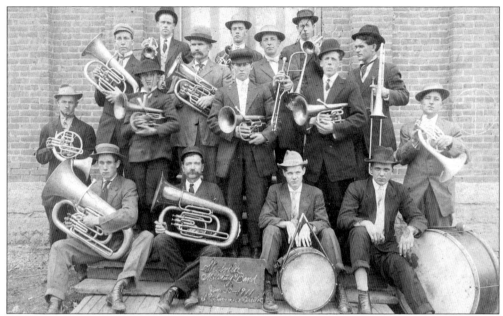

Photographed on January 30, 1911, Steelville's military band included, from left to right, (first row) Roscoe McIntosh, Walter England, Andrew Hughes, and Harold Hopkins; (second row) Raymond Stough, Lloyd Wright, George Summers, Sevel Stafford, and Arthur Taff; (third row) Clark Davis, Fred Hughes, Mr. Youngs, and George Key; (fourth row) Oscar McFarland, Lynton Griffith, and Glover Summers (director).

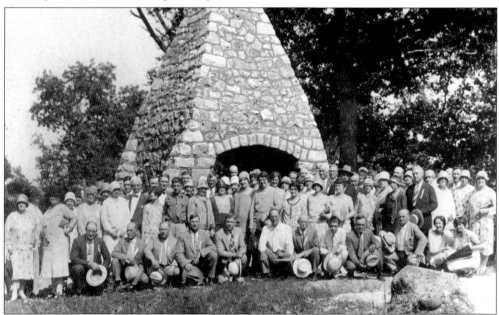

Graduates of Steelville Normal and Business Institute continued to hold reunions in Steelville between 1927 and 1940. In memory of their college, the graduates raised money and built a monument in 1929 on the site of the school. Documents and old records were placed in the attic of the monument; however, thieves later broke in. Pictured here are graduates of SN&BI in front the monument.

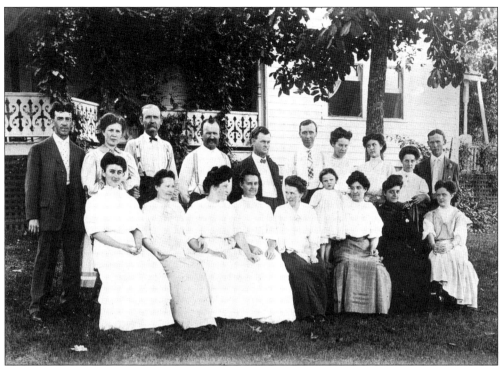

Members of this group are, from left to right, (first row) Elsie (Matlock) Todd, Ida Gibbs, unidentified, Ida Gibbs, Mrs. Lee Wingo, Missouri Arnett, Edna Mae, unidentified, and Faye Wingo; (second row) Calvin Todd, Cora Gibbs, Matt Gibbs, H. P. Gibbs, Lee Arnett, two unidentified people, Geraldine Coffee, and Clarence Gibbs.

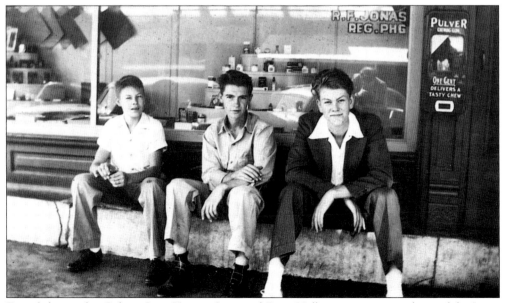

From left to right, Calvin Carr, Kermit Carr, and Earic Halbert are sitting in front of the Jonas Drugstore around 1935.

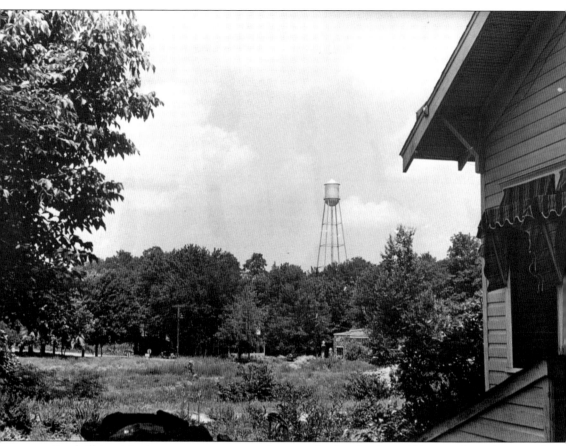

Steelville's original water tower rose over the town for decades. It could be seen for miles around and was the first thing one saw driving toward the town. Soldiers returning to Steelville from war would look for the tower, which let them know they were home. The tower was also the location of the town's siren. This would sound daily at noon and during emergencies. Volunteer firemen and police officers were informed of fires through the alarm. Today the tower no longer exists, but in 1934, when the Pittsburgh-Des Moines Company first built it, Steelvillians were able to enjoy fresh water for the first time. This is a comfort that is today taken for granted, but then it was considered a luxury. This photograph was taken by Haley Saltsman during the late 1940s.

Seven
VACATION DESTINATIONS

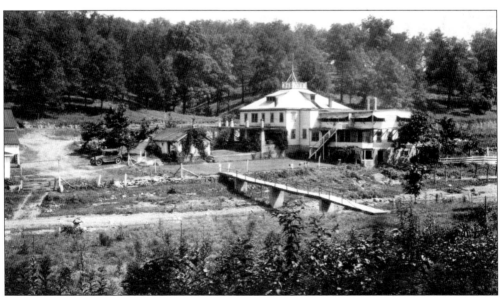

Resorts have encompassed the Steelville area for years. The first resort was Woodlock, "a health and pleasure resort," according to the December 1934 edition of *Missouri*. Eugene Woodlock, son of Irish immigrant Patrick Woodlock, remodeled and enlarged his parent's two-room house to create one of the first summer resorts in Missouri's Ozarks. Woodlock became a popular summer location during the beginning of the 20 century and saw many notable visitors, including Missouri statesman Champ Clark.

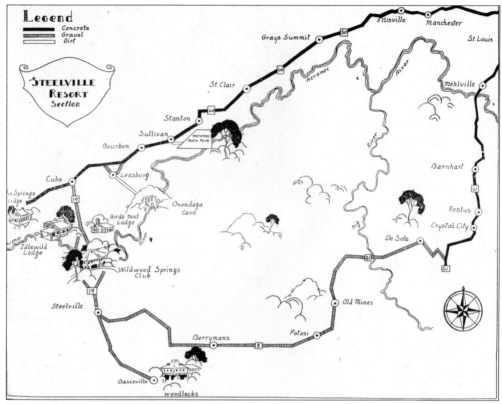

Maps and descriptions were placed in newspapers of surrounding areas to entice visitors. These maps included Steelville resorts and roads to assist travelers. This map shows most of the resorts operating in the 1920s, including Bird's Nest, Idlewild, Fox Springs, Woodlock, and Wildwood.

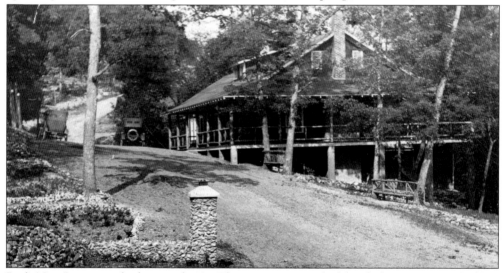

Bird's Nest Resort was built around 1921. This resort consisted of the "lodge" sitting on the bluff overlooking the Meramec River, and multiple cabins surrounding the area. At the beginning of the 20th century, Bird's Nest became a popular vacation place for residents of Chicago and a social hangout for locals. The resort became known for its dances and festivals.

92

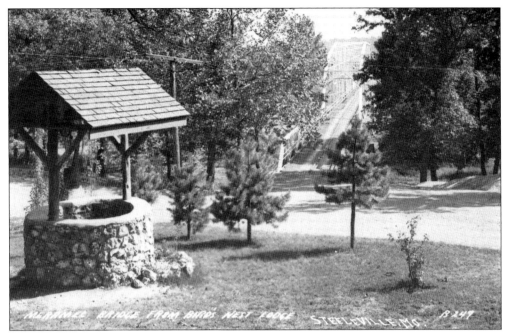

The location for Bird's Nest was chosen after the building of the Meramec Bridge. This bridge was the first in the area to cross the river and eliminated the need to ford it. After the bridge was constructed in 1914, Bird's Nest was built. The bridge created easy access from both Cuba and Steelville.

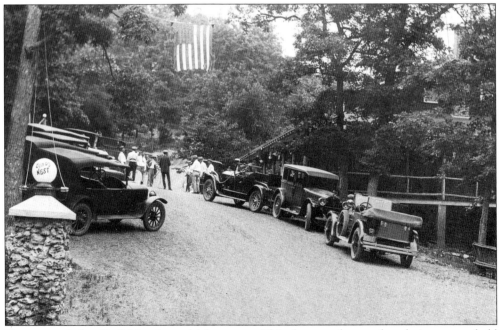

Guests traveled to Bird's Nest for multiple reasons. This photograph was taken during a party held for the Fourth of July celebrations. Guests had traveled to the resort in their cars and parked in front of the lodge. Located in the bottom left is a small globe. This lit up during the night and informed guests that they had reached the resort.

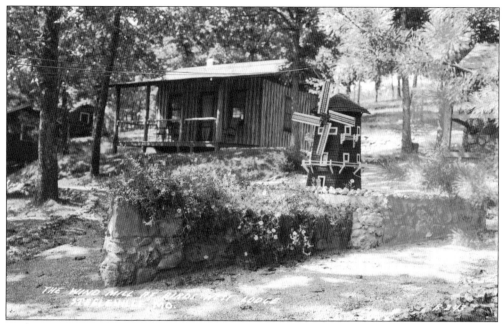

Bird's Nest guests stayed in one of 20 cabins, located on the surrounding land. These cabins had no running water, and guests were asked to use public outhouses. Showers were non-existent as well.

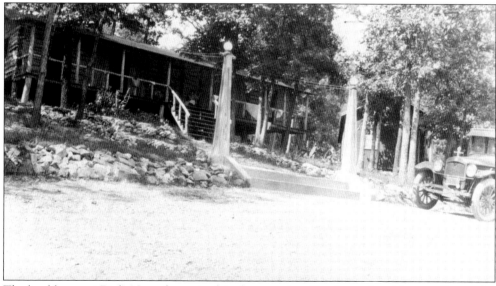

The bunkhouse at Bird's Nest, shown in this photograph, still exists today. Also notable are the light towers and the Model T at the entrance.

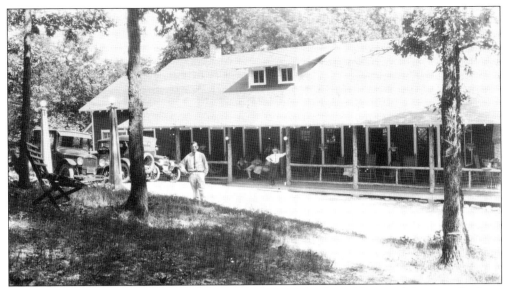

Bird's Nest Lodge was the first building guests saw upon check-in. Along with housing the front desk, the lodge was also the dining room. This was where meals and dances were held for guests and locals. These dances were what increased Bird's Nest's popularity and made it a popular hangout for vacationers and locals.

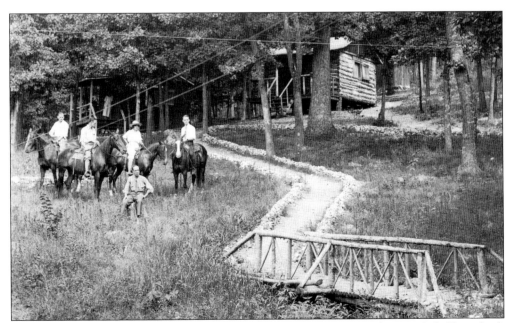

In addition to dances and festivals, Bird's Nest offered daily activities. These included horseback riding and canoeing down the Meramec River. In fact, many guests would often canoe to the resort after traveling by train to St. James and then by wagon to the river.

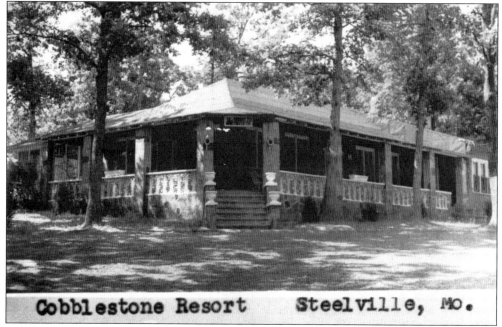

Cobblestone Resort's reception hall was built around 1937, which was after the second Meramec Bridge was completed in 1936. The resort continued to operate throughout World War II and into the present day. Cobblestone's main lodge held the front desk, along with the game and dining room.

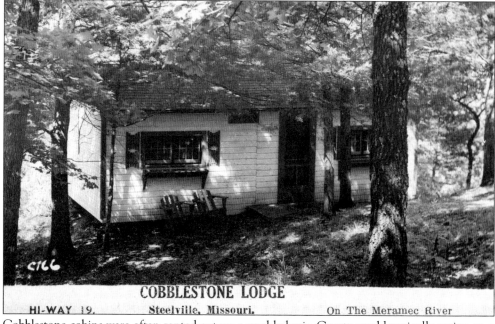

Cobblestone cabins were often rented out on a weekly basis. Guests would typically arrive on a Sunday and stay for a full week.

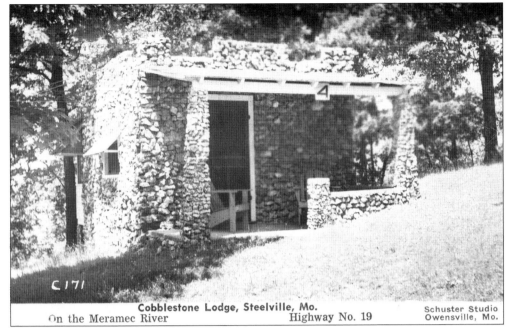

Cobblestone Lodge, Steelville, Mo.

On the Meramec River Highway No. 19 Schuster Studio
Owensville, Mo.

Along with lodging, Cobblestone offered various activities for families, including floating in a canoe down the river, which Cobblestone employees handled themselves from their property. The cabin shown in this photograph is a "rock-style" cabin, which is frequently found throughout the Ozarks and is unique to the region.

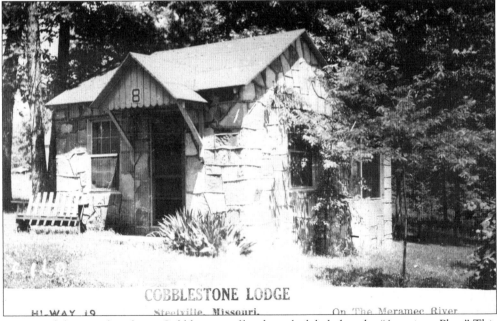

COBBLESTONE LODGE

HI-WAY 19 Steelville, Missouri. On The Meramec River

As part of the rental package, Cobblestone offered meals, labeled as the "American Plan." This meant that all three meals, breakfast, lunch, and dinner, were included. Today the resort still operates as an all-inclusive property. The Cobblestone cabin shown in this photograph is a "giraffe-style" cabin, which is known only in the Ozarks region.

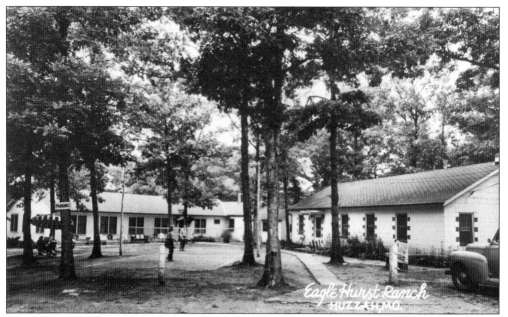

Eagle Hurst Ranch, operated by Sam Hicks, was constructed southeast of Steelville along the Huzzah Creek. Guests rented out cabins and were offered multiple activities throughout their stay. In front of the lodge was a volleyball court, shown here.

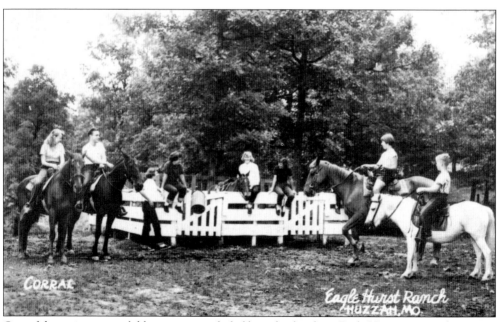

One of the activities available to guests included horseback riding. Eagle Hurst promoted its resort through postcards that guests were able to mail out.

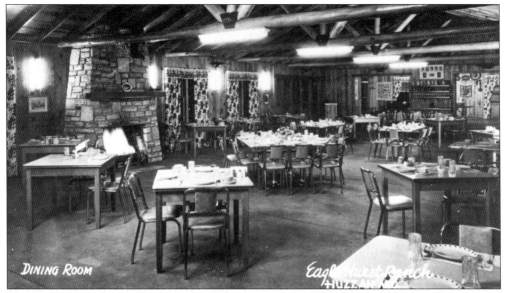

The Eagle Hurst dining room was located next to the main lodge. Guests are still served the "American Plan," which included all three meals of the day.

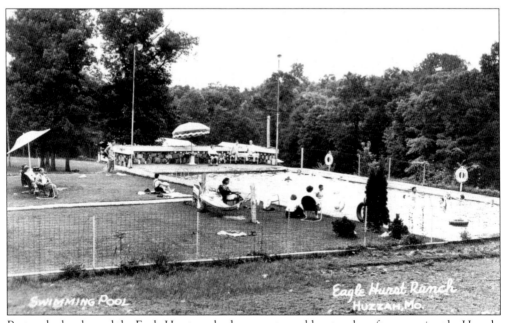

Postcards also showed the Eagle Hurst pool, where guests could go to relax after canoeing the Huzzah.

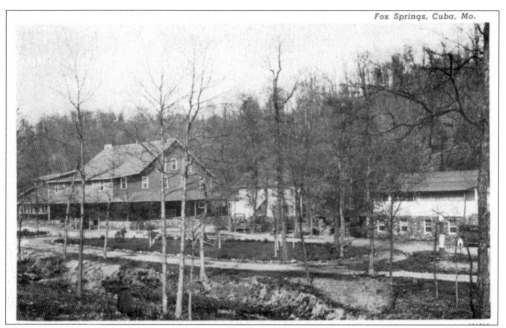

Chester and Olivette Fox built Fox Springs Lodge in 1926. During Prohibition, the resort became a popular hangout and saw a large increase in business. The Lodge was built with 10 upstairs rooms; the front desk and dining room were downstairs.

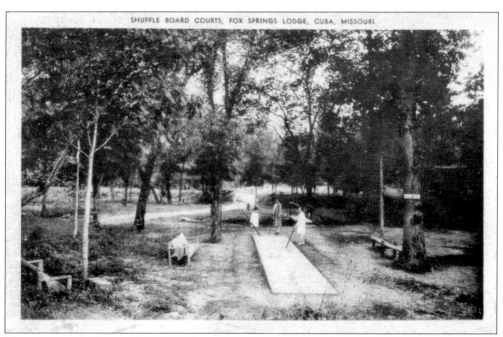

This photograph shows a shuffleboard court on the Fox Springs playground. Outdoor shuffleboard was tremendously popular in the 1920s.

100

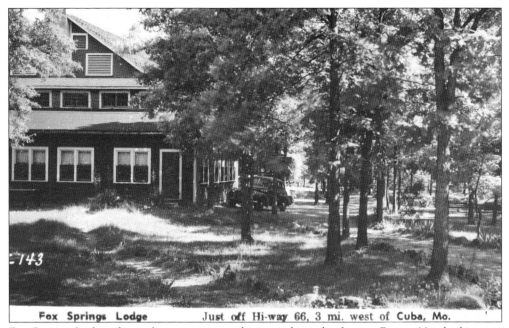

Fox Springs Lodge Just off Hi-way 66, 3 mi. west of Cuba, Mo.

Fox Springs Lodge, shown here, was a popular stop along the famous Route 66, which passes through the area.

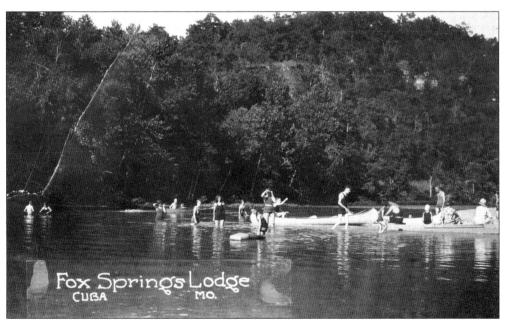

Fox Springs Lodge
CUBA MO.

In addition to lodging, the grounds at Fox Springs included a swimming pool and ball field. Many of these activities are still located on the property and are accessible to guests. Canoeing was also a popular activity. Due to Fox Spring's location along the upper Meramec River, guests had easy access to the water.

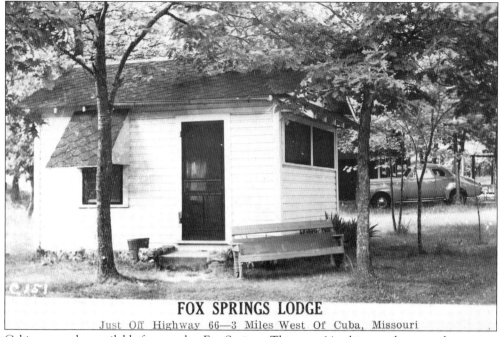

FOX SPRINGS LODGE
Just Off Highway 66—3 Miles West Of Cuba, Missouri

Cabins were also available for rental at Fox Springs. There are 14 cabins on the grounds, ranging from one to four bedrooms in size.

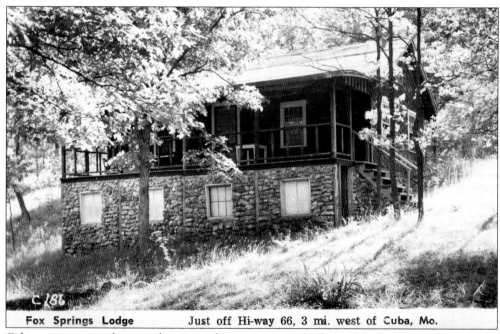

Fox Springs Lodge Just off Hi-way 66, 3 mi. west of Cuba, Mo.

Cabin guests enjoy the same luxury as those staying in the lodge. Meal plans are included in the price, and activities are offered to everyone. Air conditioning was not included at the time of this photograph.

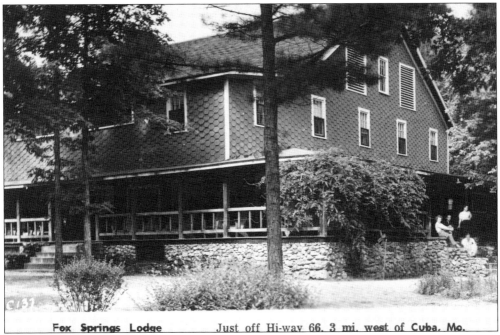

Fox Springs Lodge Just off Hi-way 66, 3 mi. west of Cuba, Mo.

Fox Springs Lodge was also a popular stop along Route 66. Many people would stop and stay at the resort to break up their travels. Today the resort is still in operation and continues to serve the "American Plan" to its guests. Cabin and indoor lodging is still available, along with many of the original activities.

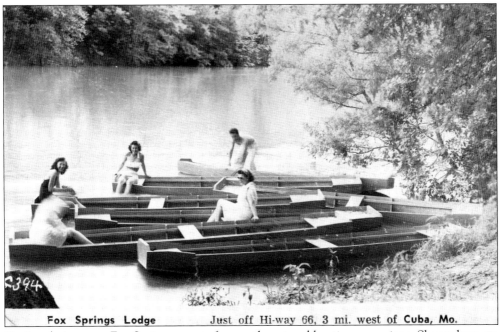

Fox Springs Lodge Just off Hi-way 66, 3 mi. west of Cuba, Mo.

During their stay at Fox Springs, guests frequently enjoyed boating excursions. Shown here are guests in jon boats along the Meramec River.

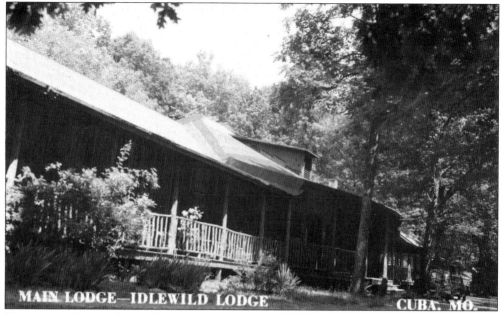

Upon seeing the popularity of resorts in the area, Jimmy Maher and Henry Robson, members of the local Angler Club, planned and opened a 22-room log clubhouse called Idlewild. Maher and Robson positioned the resort only three and a half miles away from Cuba along the Meramec River, which allowed easy access not only by roads but also by river.

Maher and Robson marketed Idlewild's 1,000-acre preserve for quail hunting and its location on the river for fishing to "sportsmen and sportswomen." The kill of the day was prepared fresh that night for dinner at Idlewild.

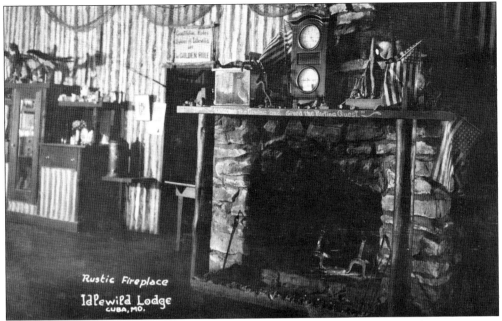

Rustic Fireplace

Idlewild Lodge
CUBA, MO.

Guests arrived at Idlewild by taking the train to Cuba. Upon arrival, they enjoyed running water in each room and meals served in Idlewild's 40-by-40-foot dining room. A popular spot to relax in the summer was Idlewild's 300-foot wrap-around veranda. During cooler weather, guests enjoyed the 8-foot Dutch fireplace, shown here.

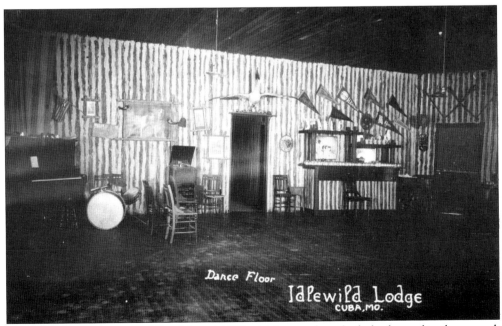

Dance Floor

Idlewild Lodge
CUBA, MO.

Guests continued to stay at Idlewild until 1987, which was when the lodge burned to the ground. It was never rebuilt.

Idlewild embraced long canoe trips, a popular activity at the time. Idlewild was a starting point for floats back to the St. Louis area. Guests would travel to Idlewild and start their journey, stopping at take-out points along the river at other resorts. One option was for guests to take a train to St. James, be transported on wagons to the Meramec River, and embark on a 35-mile float back to Idlewild.

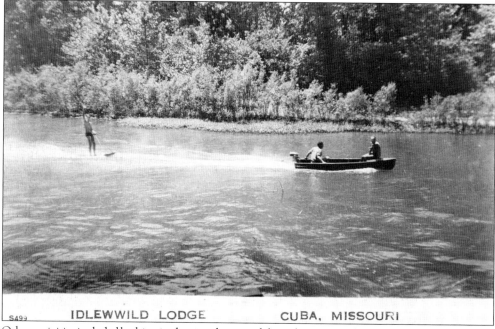

IDLEWWILD LODGE CUBA, MISSOURI

Other activities included bathing in the river, boating, fishing, hunting, and dancing. Robson was quoted as saying the resort "kept living," giving the impression that guests always had something to do.

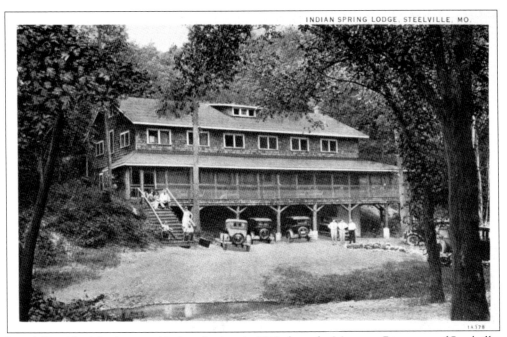

Joseph Franklin Marsh opened Indian Springs in 1929 along the Meramec River west of Steelville. The lodge was constructed with guest lodging upstairs and a dining room on the first floor.

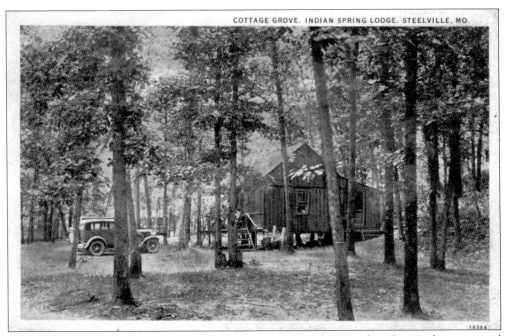

Cabins were also located on the grounds as an option for lodging. Indian Springs has remained in continuous operation; however, after the lodge burned down in the 1980s, the resort offered camping areas instead.

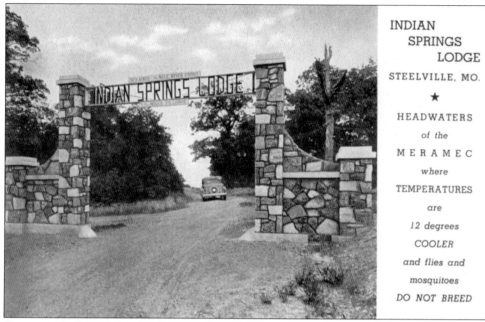

INDIAN
SPRINGS
LODGE

STEELVILLE, MO.

★

HEADWATERS

of the

M E R A M E C

where

TEMPERATURES

are

12 degrees

COOLER

and flies and

mosquitoes

DO NOT BREED

Over time, Indian Springs had multiple owners. One of the most influential owners was Robert Bass, who purchased the resort in 1970. Bass worked to increase the popularity of both the resort and canoeing along the Meramec River.

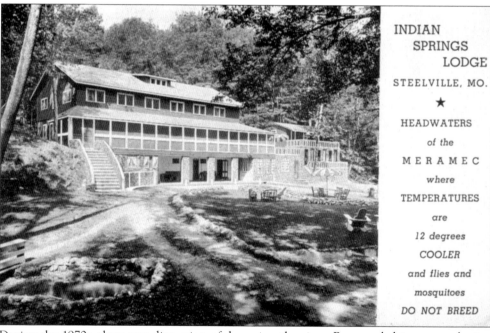

INDIAN
SPRINGS
LODGE

STEELVILLE, MO.

★

HEADWATERS

of the

M E R A M E C

where

TEMPERATURES

are

12 degrees

COOLER

and flies and

mosquitoes

DO NOT BREED

During the 1970s, there was discussion of damming the river. Bass used this as a marketing scheme to entice guests to "float the river one last time," which ultimately protected the river. To this day, the river is still at a natural flow, and Indian Springs continues to operate as a popular camping and canoeing resort.

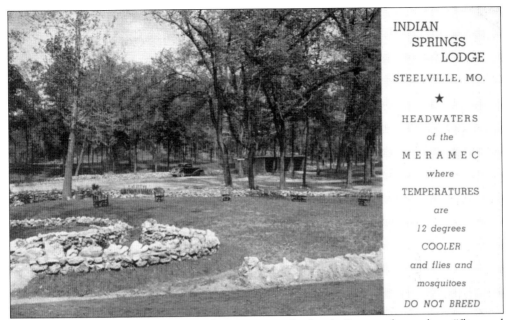

Indian Springs promoted itself through statements of a "cooler" atmosphere where "flies and mosquitoes do not breed." This may or may not have been true; however, Indian Springs does have a spring that runs through the campground.

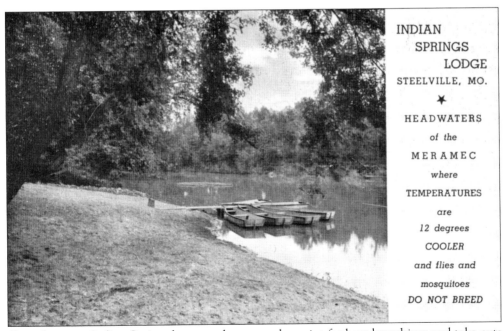

Over the years, Indian Springs has served as a popular point for boat launchings and take-outs along the Meramec River. To this day, both locals and tourists use this stretch of the river for the beginning or end of their excursions.

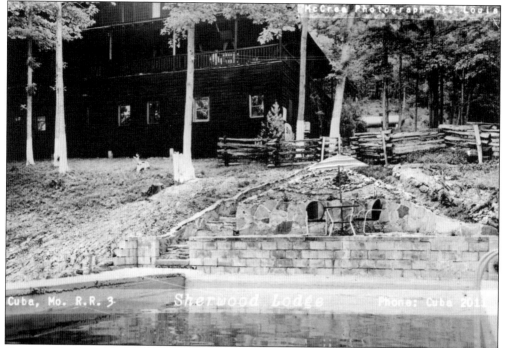

Sherwood Lodge was never really a resort but a popular hangout for Chicago hit men. A popular hit man owned the large building and welcomed fellow gangsters to stay with him. Other rumors also state that the building was used as a brothel. Today it is part of Bird's Nest, and the current owner, Jason McCormick, has restored the building and opened it up to guests.

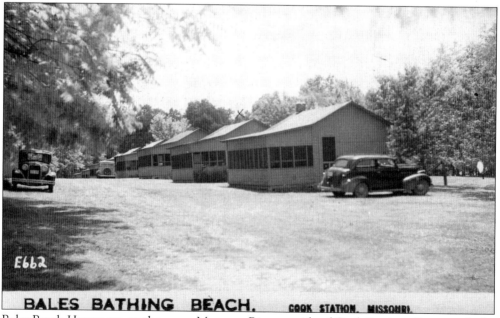

Bales Beach Houses are on the upper Meramec River outside of Cook Station. Guests took the train to the small town and were then escorted to their rented cabins.

Eight

THE END OF AN ERA

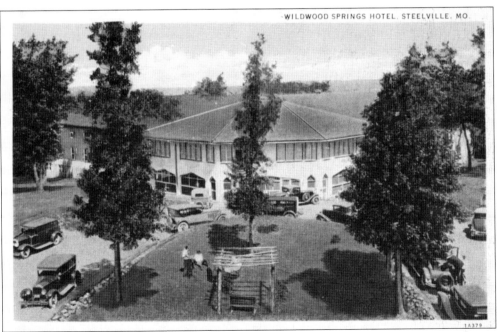

WILDWOOD SPRINGS HOTEL, STEELVILLE, MO.

Erected at a location the *Crawford Mirror* claimed comparable to Switzerland, Wildwood Springs Lodge was highly anticipated by the citizens of Steelville and the members of the Wildwood Springs Resort Association. Viewed as the grandest resort west of the Mississippi, it was believed that Wildwood could easily become a nationally famous destination. Offering multiple activities and luxuries beyond most resorts at the time, Wildwood had steady customers until the Depression hit, and hard times forced the lodge to close for many years.

On November 17, 1921, members of the Wildwood Springs Resort Association visited Steelville for the groundbreaking ceremony. These members included Duke Pohl, manager of Brevort Hotel; Herman Koch, merchant; Ray Hummel, contractor; J. W. Kuemmerle, proprietor of B&K Tire Company; Henry Recker, retired merchant; William Forester, president; and E. J. Karm, secretary for the association.

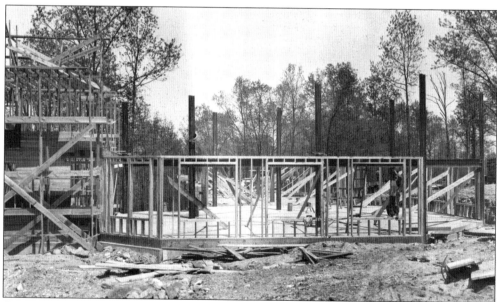

Construction of the building started immediately and was estimated to cost approximately $50,000. Along with the resort, plans were made for 300 individual cottages costing approximately another $50,000. However, after falling into financial trouble, the association went bankrupt after a short time. Then Dr. John Zahorsky and a new group bought and operated the resort until the late 1930s.

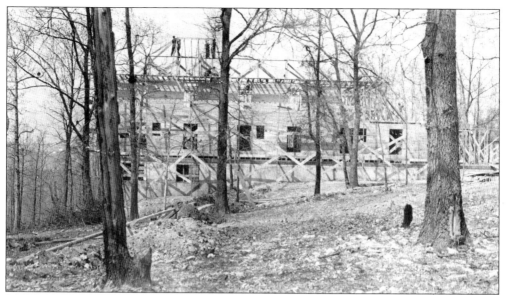

In January 1922, R. H. Hummel, contractor and member of the Wildwood Springs Resort Association, told the *Crawford Mirror* the projected finish date would be June 22, 1922. Finishing a full month ahead of schedule allowed Wildwood Springs Lodge to hold its opening day on Memorial Day 1922. Construction of what was proposed to be the largest resort in the state of Missouri was completed after a mere five months.

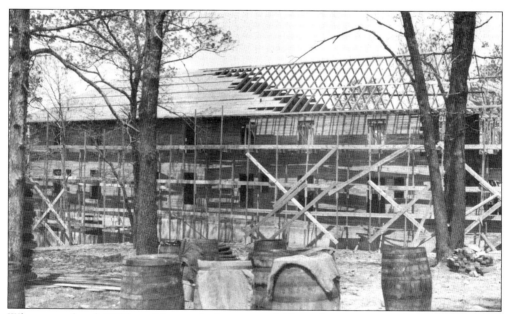

When completed, Wildwood featured a large main lobby and two wings, each 121 feet long and 44 feet deep. The wings consisted of the guest rooms, showers, and lavatories. Downstairs held 16 of these rooms, each with shared lavatories. Originally, both floors were supposed to have the same layout but due to lack of financing, shared rest rooms were created at the end of each hallway in the upstairs wings.

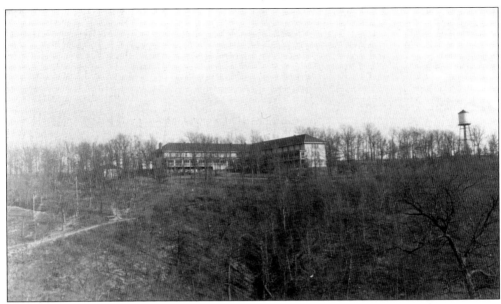

Six additional rooms, called bridal chambers, were added outside the wings in the Mezzanine area. This made a total of 53 rooms that were all described by the *Crawford Mirror* as "furnished with modern furniture, carpets, and draping," with the addition of electricity.

Surrounding acres were originally planned for development of 300 cabins, ranging from three to five rooms each. When financing failed, the land was divided into lots to be sold. Hummel, the contractor, constructed the present-day Clubhouse for George Fields in 1921, shown here on the right. He then built himself a small cottage at the end of the clubhouse drive, which later became the Boathouse.

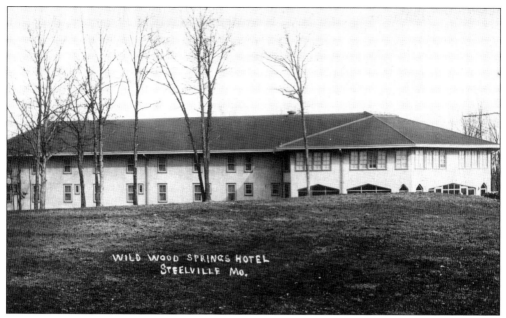

Located below the ground floor in the basement were the 32.5-by-31.5-foot kitchen, its storage room, and a 6-by-12-foot refrigerator. Servants' quarters were also found below the first floor. These consisted of two 32-by-12-foot sleeping rooms, each with its own shower and lavatory. The basement is visible from the back of Wildwood Springs Lodge, seen underneath the porches.

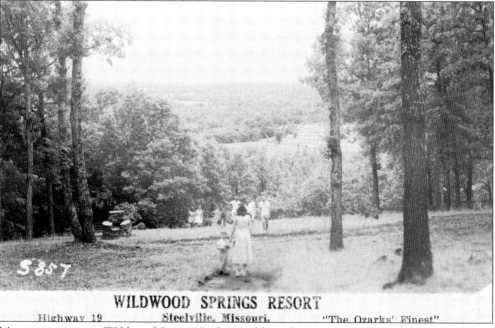

Many vacationers to Wildwood Springs Lodge would stay for one or two weeks. Some families even found themselves relaxing there for the whole summer. Steelville citizens often found themselves associating with the visitors and the resort. Many young adults found employment at Wildwood, which assisted them through high school and college. Others were able to take advantage of the local enjoyments the resort offered.

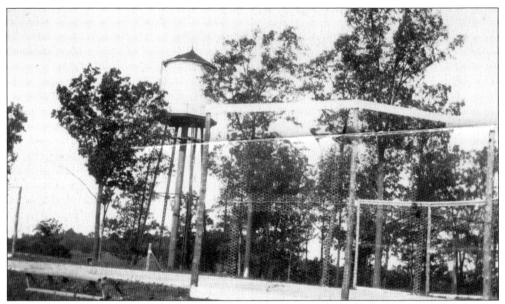

Wildwood Springs Lodge was the first building in Crawford Country with running water. This was made possible through its own water tower, pictured above, located near the tennis courts.

Large Mountain Spring, near Wildwood Springs Club, Inc.

Water was taken from the spring that flowed from the fields below and pumped up the hill from the pump house near the river to the water tower.

The work house accommodated the steam plant, which was used to create steam for the hot water steam heat system, which was used only for the first year the lodge was open, as it was found too expensive to operate with the lack of winter business.

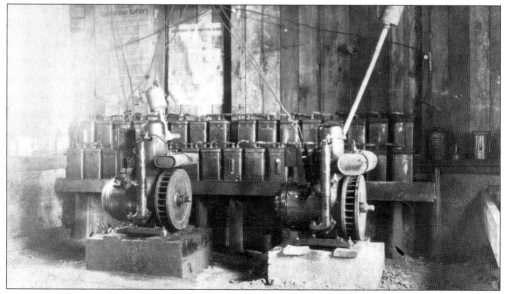

Along with having the first running water, Wildwood Spring Lodge also had its own Delco plant generator, which allowed the lodge to be fully wired for electricity. This was also located inside the workhouse, which was at the end of the lodge on the dining-room side.

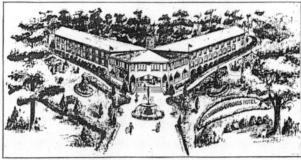
DINING

WHOLESOME food, well cooked, and daintily served, every day in the season, has given Wildwood Springs Club an enviable reputation for its meals and din-ing-room service.

The beautiful, spacious dining room coupled with a ve-randa overlooking the Meramec, and the miles of entrancing Ozark scenery, add zest to a meal after an active day of out-door sports.

Nearby farms supply the hotel with fresh vegetables, ber-ries, fruit, poultry, eggs, milk, and cream. These farms are under the supervision and inspection of the President of Wildwood Springs Club.

The kitchen and serving rooms have modern equipment, are kept spotlessly clean, and are always open for inspection.

Transient guests and all people who happen by just for a meal, are particularly welcome, and will receive the same courteous attention as do the regular guests.

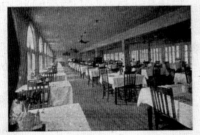

The Dining Room

Advertisements were a way for Wildwood Springs Lodge to inform St. Louisans and others of the resort. The ads mainly focused on Wildwood's ability to offer a large amount of luxuries that were only a short distance from home. These luxuries included such things as electric lighting, private showers and toilets, and steam heat. Advertisements also pushed the large number of activities provided by the resort.

Created to seat 400 people, the dining room was designed with French-style windows along both sides. This allowed the beauty of nature to been seen easily, as well as letting in an abundant amount of light.

118

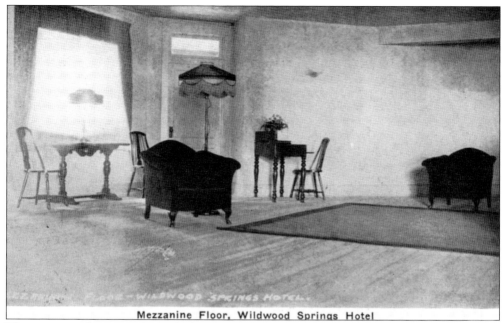

Mezzanine Floor, Wildwood Springs Hotel

The mezzanine floor wraps around a balcony, which overlooks the dance floor. A large skylight was placed in the ceiling above this floor, allowing natural light to shine through. The six mezzanine rooms were constructed as "bridal suites" and featured private showers.

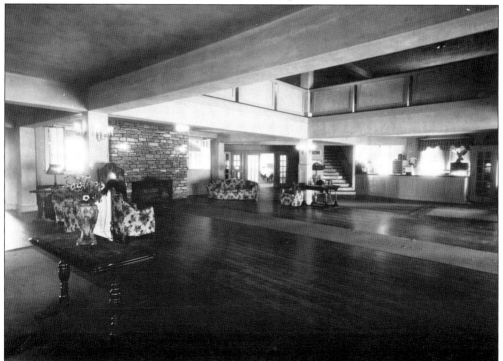

The dance floor offered great amusement during the evenings as the Wildwood Springs Orchestra played. During the day, the lobby was a peaceful place to relax. With the Ozarks's cool mornings and evenings, the lodge would start fires in the large stone fireplace, creating a relaxing atmosphere.

This small brochure illustrates the concept of Wildwood conforming to nature. During the construction of the building, materials were used in order to "harmonize with its surrounds," according to the *Crawford Mirror*. This included using "fire proof mangiest stucco with natural-color pebble dash for the outside covering" and a green-gray slate for the roof. The theme of harmonizing with nature was taken inside with hardwood floors throughout the lobby and dining room.

Opening day for Wildwood Springs Lodge was held on Memorial Day 1922. Combining Steelville's Memorial Day services with the opening of the lodge, more than 2,500 people gathered on the resort's grounds. The *Crawford Mirror* claimed it to be "remembered as one of the outstanding dates in Crawford County's history." Leading the parade on Memorial Day was Doctor A. L. Barnard.

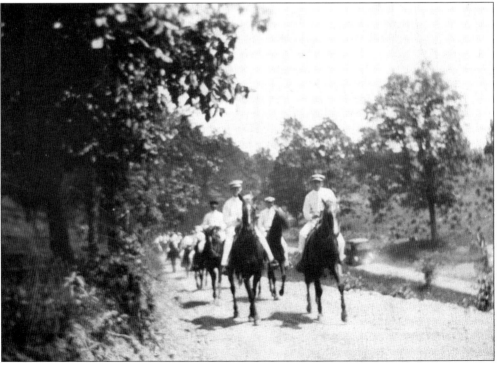

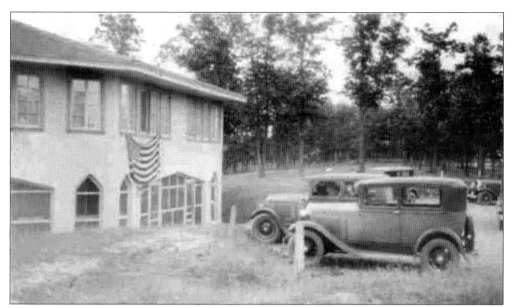

After starting the day off with a parade, observers were welcomed to enjoy the barbecue and picnic offered at Wildwood Springs Lodge. The mayor of Steelville, William Underwood, welcomed the crowd with a speech, while William Forester, president of Wildwood Spring Resort Association, proudly gave tours of the lodge.

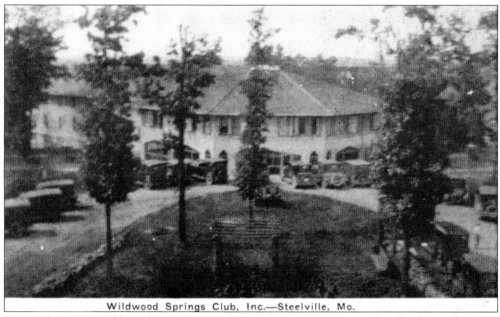

Wildwood Springs Club, Inc.—Steelville, Mo.

During the 1920s, Wildwood was an extremely popular destination and was "the place to be seen." It was a unique experience for visitors because of its extreme elegance, size, and amenities.

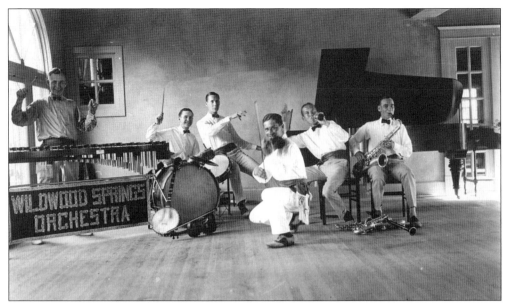

The Wildwood Springs Orchestra devoted its time to entertaining the customers of Wildwood. J. Haskell McInnis, a gifted musician who served in John Philips Sousa's band during World War I, was assigned to gather the original Wildwood Springs Orchestra. The six men are, from left to right, Virgil Whitworth (xylophone), McInnis (drums), Tom Muench (piano), Leo Lipzer (violin), J. Leon Gale (banjo and saxophone), and J. M. Wasmund (saxophone and clarinet).

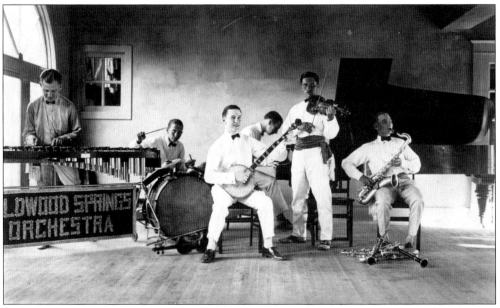

As time moved on, so did the members of the orchestra, and some would become well-known talents. This included men such as Gordon Jenkins, who became a Hollywood composer; Harold Stokes, later the founder of his own band; and Russ David, a popular St. Louis band member. In this photograph, Leon Gale is on drums, and McInnis, who played a variety of instruments, is on Banjo.

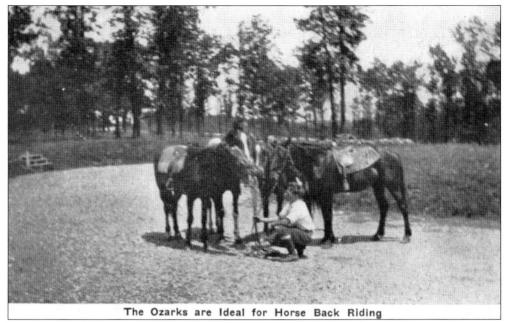

The Ozarks are Ideal for Horse Back Riding

In fear of the Wildwood Springs Resort Association overlooking horseback riding, Dr. A. J. Barnard purchased the lot adjacent to the resort. On this land, he created the Central Riding Park and kept 20 saddle horses. Here, citizens and visitors were able to learn how to ride on the half-mile course.

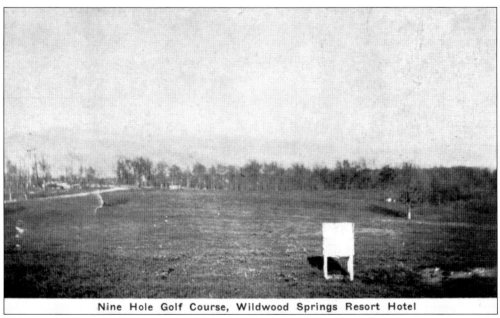

Nine Hole Golf Course, Wildwood Springs Resort Hotel

Wildwood Springs Lodge also offered a nine-hole golf course with sand greens located near the horse barn. This included obstacles, such as a pond. The golf course provided enjoyment for visitors and locals.

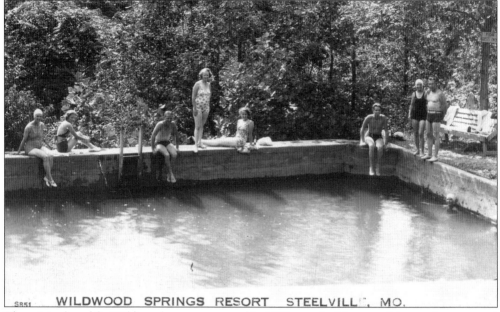

The original pool for Wildwood was constructed in 1922 near the Meramec River and was created by damming a spring and filling a concrete structure with the spring's water. Guests could access the pool by stone steps leading down the bluff.

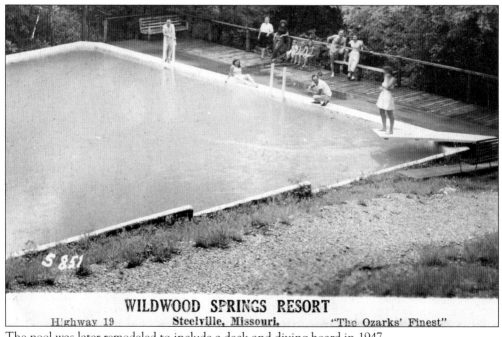

The pool was later remodeled to include a deck and diving board in 1947.

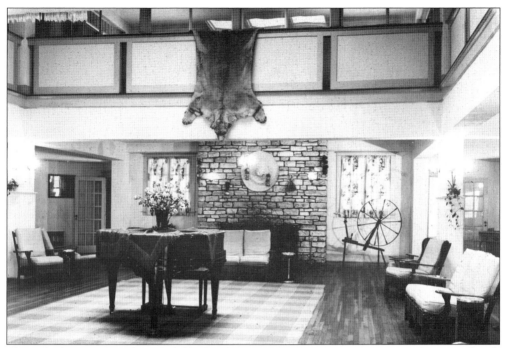

Through the years, Wildwood's lobby has been a center for entertainment. In this room bands have played, guests have danced, and people have simply relaxed. When the Depression hit the United States, times were hard, and the lodge closed for many years.

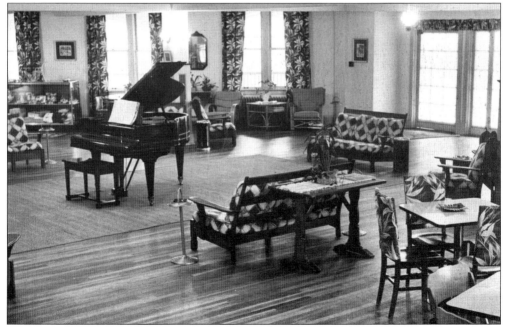

During World War II, the lodge housed young women who created bandages for the war. It is rumored that young men tried to climb up ladders into the windows after hours to visit the young women. After the war, Ben and Sonia Finkel, a couple from St. Louis, purchased the building. They remodeled the lobby in the 1950s, as shown here. The couple operated the hotel until the early 1980s.

From left to right, Ben Finkel, Cato, Sonia Finkel, and an unidentified customer sit in the dinning room enjoying dinner. Cato, unmistakable at 6 feet, 7 inches, was hired as the chef for Wildwood during the ownership of the Finkels.

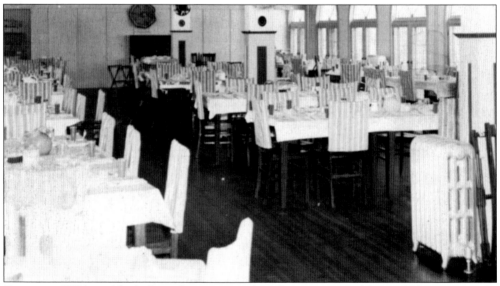

Cuisine at Wildwood had always been outstanding, but Cato was able to add his own touch. Every Sunday lunch, Cato cooked his famous fried chicken, which guests loved. Wildwood was a large part of Cato, just as Cato was a part of Wildwood. He stayed in an upstairs bedroom above the kitchen and worked with the Finkels until 1982, when he passed away due to a heart attack while on the back porch.

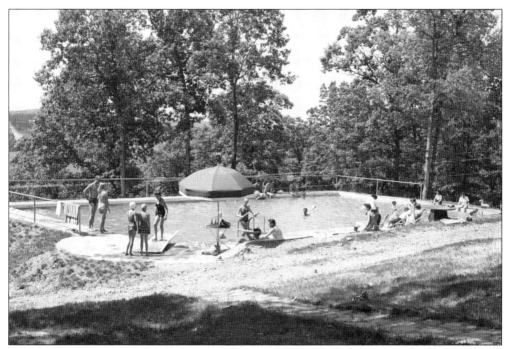

In the mid 1950s, Ben Finkel chose to build a new pool closer to the building, which included a sandstone patio. At the time of construction, the pool was the largest and deepest in the Ozarks and possibly may still be.

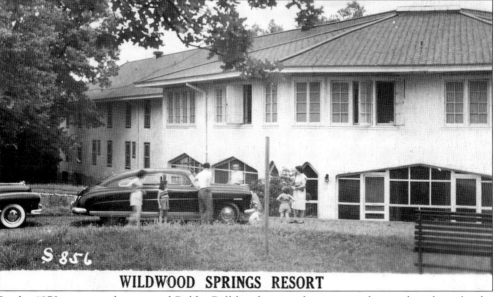

WILDWOOD SPRINGS RESORT

In the 1970s, a young boy named Bobby Bell lived across the street and started working for the Finkels. Throughout the years, the boy became close to the couple and to the lodge. After seeing the lodge close and sit empty, the Bell family decided to purchase the building. In 1993, they reopened Wildwood. Over the years, Bob worked to bring back the ambiance and romance of the resort. Once again, Wildwood has become a place for families to relax, partake in different activities, and enjoy music.

www.arcadiapublishing.com

MAP SEARCH

Discover books about the town where you grew up, the cities where your friends and families live, the town where your parents met, or even that retirement spot you've been dreaming about. Our Web site provides history lovers with exclusive deals, advanced notification about new titles, e-mail alerts of author events, and much more.

MADE IN THE
USA

Arcadia Publishing, the leading local history publisher in the United States, is committed to making history accessible and meaningful through publishing books that celebrate and preserve the heritage of America's people and places. Consistent with our mission to preserve history on a local level, this book was printed in South Carolina on American-made paper and manufactured entirely in the United States.

This book carries the accredited Forest Stewardship Council (FSC) label and is printed on 100 percent FSC-certified paper. Products carrying the FSC label are independently certified to assure consumers that they come from forests that are managed to meet the social, economic, and ecological needs of present and future generations.

FSC
Mixed Sources
Product group from well-managed forests and other controlled sources

Cert no. SW-COC-001530
www.fsc.org
© 1996 Forest Stewardship Council

Find Your Place in History.